STORYTELLING
TECHNIQUES
——— *for* ———
DIGITAL
FILMMAKERS

Plot Structure, Camera Movement,
Lens Selection, and More

Ross Hockrow

AMHERST MEDIA, INC. ■ BUFFALO, NY

Copyright © 2014 by Ross Hockrow.
All rights reserved.

Published by:
Amherst Media, Inc.
P.O. Box 586
Buffalo, N.Y. 14226
Fax: 716-874-4508
www.AmherstMedia.com

Publisher: Craig Alesse
Senior Editor/Production Manager: Michelle Perkins
Assistant Editor: Barbara A. Lynch-Johnt
Editorial Assistance from: Carey A. Miller, Sally Jarzab, John S. Loder
Production Assistance from: Jeff Medford
Business Manager: Adam Richards
Marketing, Sales, and Promotion Manager: Kate Neaverth
Warehouse and Fulfillment Manager: Roger Singo

ISBN-13: 978-1-60895-586-2
Library of Congress Control Number: 2013905051
Printed in The United States of America.
10 9 8 7 6 5 4 3 2 1

Notice of Disclaimer: The information contained in this book is based on the au-
thors' experience and opinions. The authors and publisher will not be held liable
for the use or misuse of the information in this book.

Check out Amherst Media's blogs at:
http://portrait-photographer.blogspot.com/
http://weddingphotographer-amherstmedia.blogspot.com/

Table of Contents

8. Types of Stories

9. Audio

10. Editing

Conclusion

Introduction

"Once upon a time. . ." When we see those words appear on a movie screen or read them in a book, we know we are in for a great story. More than just words, this phrase functions almost like a brand; over time, we have been trained to hear "once upon a time" and think "story."

Understand the "Why"

Let's put aside the story for a moment and begin to analyze the "why" of the above statement. Things don't stop with "once upon a time." In fact, stories are such a significant part of our daily lives that they are nearly ingrained in our DNA—whether you're The Grinch Who Stole Christmas or Mr. Jolly-Go-Lucky. Don't believe me? Let's examine.

Frosty the Snowman, the Easter Bunny, Santa Claus, the Tooth Fairy, the boogie man—who are these characters? And why do we almost instantly, without even a moment's thought, know the entire back story of each fictional figure when we read their name? It's because early in our lives we were told stories about them. Some were more intricate than others, but we always believed every word. In fact, it wasn't even belief, it was *knowledge*.

I can think back to being 10 years old and rationalizing that Santa Claus *must* be real because there's no way my parents could afford all those gifts. The greater impossibility, in my mind, was the idea that he was fictional, not that he was real. I was too young to understand the concept of a credit card, or money for that matter. The point is, I wanted to believe it was real—just like everyone else did. (And this is not just a few of us; we live in a nation so obsessed with the legend of Santa Claus that we've built a billion-dollar industry around it. That is the power of stories.) Santa Claus hardly stands alone, either—there are plenty more like him. So why is this?

People Need Stories

Consider a time before humans could read or write. Did we just look at each other and use telepathy to transmit

our knowledge? At one point, stories were how we communicated our experience and history. It was so effective that we still rely on this method today. Before your child can read or write, they learn through the stories you tell them. "Timmy, please don't ever touch the stove when it's red like that." Do you think that statement alone would teach Timmy not to touch a hot stove? Of course not. Mom had better have a story to support that statement (or Timmy will make up his own). This is where it starts.

Stories come from mankind's undying need to explain things.

As young children, we want explanations. It's not enough that Santa brings us presents every Christmas— we must know more, and so the story grows. "How does he get to our house, Mom?" (We have the birth of the reindeer and Santa sliding down the chimney.) "Where does he get all the toys, Mom?" (Here come the Elves and the North Pole!) See what happens? Stories evolve based on the questions asked.

That one powerful word ("Why?") sends us down the rabbit hole. Stories come from mankind's undying need to explain things.

From that, it follows that stories are an effective way to deliver a message— something the entertainment industry and media know well. Consider the news. Have you ever wondered why they call it a "news story" rather than "the news facts"? It is because the information is presented in a way designed to trigger the viewer's emotions and make the facts feel personal. When it's done well, it hits that inner storyteller button in your brain. What is the goal? To make sure you do not change the channel. It's that simple.

Our Minds Are Wired for Stories

Storytelling is a collaboration between the storyteller and the story seeker. When your brain is fed information, it immediately starts piecing together the facts to create a story. In fact, your brain is always telling itself a story. If you don't believe me, put this book down and take a nap. When you wake up, write your dreams down in a notebook. Then read it back to yourself. Ridiculous, right? A dream is a story that your brain tells itself. In this case, *you* are the storyteller of the dream— which means that telling other stories is well within your grasp as a human. Storytelling is like an instinct for the human mind.

We all love a good ghost story, right? Some of us believe in ghosts and some do not, but at one point or another, most of us have felt like

we've seen a ghost. Without ghost stories, we probably wouldn't arrive at the same conclusion.

Allow me to bring a little science to the argument. Sensory deprivation is the deliberate removal of stimuli from one or more senses. This can happen as a result of damage to one of the sensory organs, but the same effect can also be created temporarily as a form of therapy. In a sensory deprivation tank, for example, you are placed in a water tank in the dark. In this environment, you cannot hear, see, smell, or taste—you are only feeling the water. As the sensory input is removed from the equation, your mind begins to compensate. This often results in hallucinations.

Now, let's leave the tank and come back to reality. Have you ever seen a ghost in broad daylight? Doubtful. They always seem to show up in the dark, right? This is sensory deprivation happening on a smaller scale. When one of the senses is removed, our minds rely more heavily on the remaining senses to fill in the blanks. So when we're sitting blind in a pitch-black space and think we see a ghost, we *did* see a ghost—or at least our minds created one.

While this is a perfectly rational, scientific explanation, it's not a very good story. Therefore, it's natural to prefer to think that there really was a ghost out there. Thus, ghosts are pop-ular and marketable. (There's another billion-dollar industry: Halloween.)

Sensory deprivation may not be a story, but it does show that our mind instinctively believes what it "sees." Understanding this is very important for being a storyteller. The mind will always give you the benefit of the doubt, because the mind wants a story.

Stories are a way to present a message we are trying to deliver. This is why there are news stories. This is even why the Bible was written. The Bible could have been presented in bullet points and said the exact same thing, right? So why wasn't this done? It would only be half as popular and much less believable. Stories are how we touch the soul—and when we touch the soul, we can get our audience to buy into what we are saying.

The Path to Successful Filmmaking

Understanding stories, and the telling of them, is the way to become a successful filmmaker. In every good film lies a good story. In every good story lies many sub-stories. We must assemble each moment as a story. Keep it in your mind that people want stories, people need stories, and people will help you tell your story. Without a story, there are just random facts that deprive people of connecting with our message.

1. The Structure of a Story

It is important to understand the basic structure of a story. Whether we follow this religiously, or just use it as a guideline to help us translate something a little less traditional, we need to understand the fundamental elements and their arrangement. Let's talk about two different story structures, then break down each of the basic parts.

Aristotle's Unified Plot

Conceptualized in 350BC, Aristotle's theory of the unified plot consists of a beginning, a middle, and an end. This is a pretty simple, linear concept: the story begins, works up toward the middle (the climax), and then wraps up with an ending. What is there to be analyzed? This is how we think about things in life.

What we will focus on, especially when talking about filmmaking, is that this gives us three linear ways to tell a story (for more on linear *vs.* non-linear story types, see chapter 8). The first option is to tell the story in chronological order, which is self-

The most basic form of storytelling is told in the form of a pyramid shape.

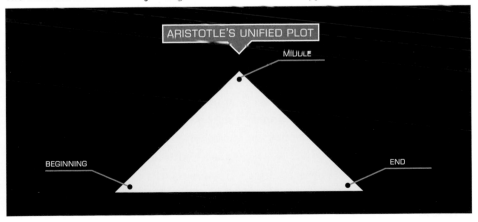

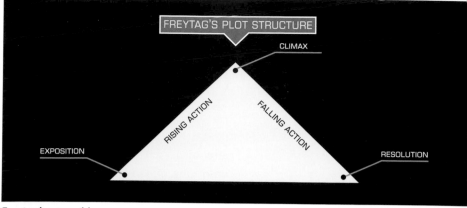

Freytag's pyramid.

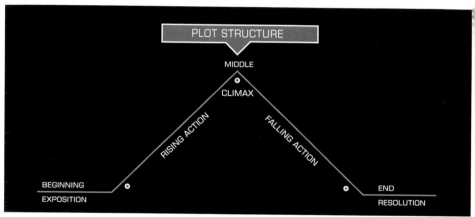

Freytag's pyramid (extended).

explanatory. The second option is to tell the story through flashbacks (this hints at a non-linear story, but the information is still divulged in a linear fashion). The third option is to drop the viewer, without any buildup, into the middle of the story and tell the story from there (this often happens in dreams). For these stories, the "how we got here" or "what lead us to this point" is assumed. Can we leave that up to the viewer? Yes. This is often done by design to keep the viewers on their toes and make them play catch-up for the rest of the story. It's a tricky way to get your viewer involved from the beginning.

Freytag's Plot Structure

Almost two-thousand years later, playwright Gustav Freytag modified Aristotle's theory. Freytag's additions of rising action and falling action take the plot system from three to five

points. We commonly see this structure in our modern stories, which reflect the build-up to the climax and also the descent from the climax to the resolution. Freytag's pyramid is often modified to extend before and after the rising and falling actions, adding the exposition and resolution.

Plot Structure in Practice

Let's break down each of the five categories and apply them to real-world situations. Many times we are in control of a story because we use a script. But what if we are at a live event, such as a wedding? Then we must recognize the story structure so we know what pieces to capture in order to replicate the plot-structure pyramid as best we can.

Exposition. Let's start with the exposition—the beginning. Many people, including myself, think this is the most important piece of the story. We have all heard the phrase that first impressions are everything. Stories work like a job interview. If you walk into the interview, prop your feet up on the table, and belch a few times, chances are your charming answers during the interview will not reverse that first impression. Likewise, if your story starts out with a boring premise, chances are you will be unable to reel your audience in later. Much of the quality of your beginning weighs on the actual concept of your film.

If your idea is intriguing, it will most likely have elements that would entice your viewer in the beginning.

Characters. Characters are the single most important part of a story because they are the way viewers transcend themselves into the story. (No one can relate to being a chair, after all.) Viewers relate to people, emotions, experiences, love, loss, and excitement, so characters are the way you grab the viewer. (We'll look at the points of view from which to tell your story in chapter 8.)

> We must recognize the story structure so we know what pieces to capture.

Setting. One of your main objectives is to develop the characters, but it is important to establish the general personality and makeup of the characters in the beginning. To do this, you will identify the setting. This is often the first thing you do. Think about what people do in real life when they walk into an unfamiliar place. They ask themselves, "Where am I?" The setting establishes the tone with which you make your film feel real—your critical goal as a filmmaker.

Relationships. The next step is to establish the characters' positions and relationships with one another. It is important to do this in the begin-

ning. Before you get to the meat of the story, these relationships need to be common knowledge. Then, if a relationship changes later in the story it will draw attention to itself because it notably changed. The change won't have the same effect if you failed to establish your characters well in the beginning.

The Hook. You also need a narrative hook. This is an initial conflict, but it bleeds into the next part of the structure—so, for the sake of filmmaking, it is best to introduce the conflict (or exciting force) early on so your viewers know what they are watching. One of the worst things you can do is *accidentally* mislead your viewers.

Rising Action. Let's move into the rising action of the story. This is a series of events that lead to the climax. Often, this takes the form of a conflict or crisis, but if you have a happy story (such as a wedding story from a live event), the rising action could take the form of an anticipatory sequence of events that lead to the obvious climax.

For this example, we will focus on the conflict—a force people love because it spawns triumph. Even in the wedding story, you can make the

story more emotional by finding conflict. For example, if your climax is the groom reading his very own romantic vows to his bride, the conflict could be his struggle to write them. Conflict does not have to be associated with something horrible, just something that needs to be overcome.

Make the viewer feel as if they are going through that conflict *with* the character.

Your job in telling the rising action is to add to the conflict as much as possible. Make the viewer feel as if they are going through that conflict *with* the character. You will also want to complicate the climax, creating a sense of mystery or suspense. The intensity of your story should build the most during the rising action. And keep this in mind: if your rising action is unsuccessful, so is your climax. It is very important to build the rising action correctly. Otherwise, your climax will not be climactic.

Climax. Now we move on to the climax. This is simply the turning point of the story. This is the most intense moment of the story either mentally or in terms of the action. This part of the story is also largely based on your original concept. It is connected heavily to the beginning and is the centerpiece around which the

Exposition Objectives
- Establish the characters.
- Establish the setting, the mood, and the conditions existing at the beginning of the story.
- Establish the characters' positions in the story and their relationships with one another.
- Introduce the exciting force or conflict.

story is built. Every decision you make in the storytelling process involves the climax.

Falling Action. While the climax is the most intense moment, it is usually not the end of the action or intensity. Sometimes, filmmakers bridge the falling action in with the climax to create a longer climax. I am guilty of doing this quite often—but please understand that the climax and falling action are two separate parts. Once the climax is over and done, a clear end to the story should be in sight. If new conflicts are introduced, they should not be dramatic enough to take our eyes off the coming resolution. The end should be inevitable.

Resolution. In the resolution, your job is to tie up all the loose ends, threading the story together. If you also give your viewer a few enlightening moments during the resolution, they will appreciate the story much more. Be very careful during the ending of the story; it's your most vulnerable time as a storyteller. Keep the resolution short. If you let the end drag on, all of your hard work can be undone.

The Nature of Conflict

When stories fall apart, it's often during the rising action phase. Introducing the conflict is a great way to keep your story flowing like a river. "Conflict" is a word we have been tossing around quite a bit, but let's define it

Acts 1, 2, and 3

In filmmaking, we often think of the structure of a story in terms of acts 1, 2, and 3. This is just a different way of explaining the same story structure we've studied throughout this chapter—it's essentially the Aristotelian structure. Act 1 is the exposition, act 2 is the climax, and act 3 is the resolution. But no matter what structure you use, you must have a conflict.

more concisely. The conflict is essentially the dramatic struggle between two forces in the story. We are going to focus on six types of conflict:

1. Relational conflict
2. Situational conflict
3. Inner conflict
4. Paranormal/possibility conflict
5. Cosmic conflict
6. Social conflict

After I describe each conflict, I will assign a movie to watch that falls into that category. This way you can see the conflicts in action. Even if you have already seen the movie, I would recommend watching it again with the conflict in mind so you can see how the story builds to it and falls from it.

Relational Conflict. Human *vs.* human is a very popular storytelling technique. In this conflict, there are two characters trying to achieve the same goal. One is the protagonist,

Required Viewing

Relational Conflict

Nature of conflict: Human *vs.* human
Movie to watch: *The Social Network* (2010)
What to keep in mind: This movie is about the creator of Facebook and the people trying to bring him down. There are several human vs. human conflicts in this film.

Situational Conflict

Nature of conflict: Human *vs.* environment
Movie to watch: *Inception* (2010)
What to keep in mind: The main character struggles to control the dream-world environment and do what no one else thinks is possible within it.

Inner Conflict

Nature of conflict: Human *vs.* self
Movie to watch: *The Aviator* (2004)
What to keep in mind: The main character struggles with OCD, causing his major internal battle.

the main character. The plot revolves around this character, with whom the audience should most relate. The other character is the antagonist, who acts in opposition to the protagonist. The existence of these two characters automatically creates conflict, since only one of them can achieve the goal.

Here are some examples of what I'm talking about:

- The hero (protagonist) and the villain (antagonist) want the same woman, but only one of them can have her.
- The hero wants to accomplish a goal. The villain wants to see the hero fail.
- The hero plays for a team. The villain is the entire opposing team.

Situational Conflict. In situational conflicts, humans face the environment. The characters within the story disagree on how to handle the conflict the environment has presented to them. The conflict is usually very dramatic or even life-threatening, but it does not have to be. The hero usually finds the inner strength to lead the rest of the characters to the triumph. Some examples of this conflict are:

- The house is on fire and the hero's dog is trapped inside. He wants to save his dog, but his friends don't want him to go back into the burning building.
- After an earthquake, there is disagreement among the characters on how to get to safety or survive.

Inner Conflict. In inner conflicts, we see the protagonist in a mental

struggle against himself. Inner conflict is a very popular device, and it's relevant in almost every story. To me, it's one of the most effective ways to develop a strong main character. I find people identify with this conflict the most. Here are some examples of inner conflict:

- The hero lacks confidence, making it difficult to handle the task at hand.
- The hero acts against his/her belief system and struggles with guilt.
- The hero is getting married and wants to write a letter to his bride but is struggling to think of the words. (This is for all of you wedding filmmakers. It is very easy to find conflict on the wedding day; sometimes you are looking right at it without seeing it happen.)

Paranormal/Possibility Conflict. This type of conflict, in which the hero must push the limits of what he believes to be possible, has gained steam over the years. This is the conflict we see when humans confront paranormal encounters or highly advanced technology. *The Matrix* is a great example of this. You could throw this film in a few conflict categories, but the core issue is that Neo, the protagonist, must push the limits of what everyone perceives to

be possible if he is to fulfill his destiny as "The One."

- The hero thinks he can break the record for fastest man alive, but no one believes him.
- Michael Jordan thinks he can play in the NBA at age 50.

Cosmic Conflict. The human interaction with destiny or fate can offer up

Required Viewing

Paranormal Conflict

Nature of conflict: Human *vs.* paranormal
Movie to watch: *The Matrix* (1999)
What to keep in mind: In order to save the world, the main character must overcome what he thinks is possible.

Cosmic Conflict

Nature of conflict: Human *vs.* destiny/fate
Movie to watch: *Deja Vu* (2006)
What to keep in mind: It may not feel like man *vs.* fate—but keep watching. The main character must confront and redefine his viewpoint on destiny.

Social Conflict

Nature of conflict: Human *vs.* group
Movie to watch: *Remember the Titans* (2000)
What to keep in mind: To keep his job, the coach must unite two groups of players who dislike each other.

the deepest of conflict. This usually occurs between the main character and a supernatural force. Remember that conflict does not necessarily have to be resolved; the resolution has no effect on the conflict. If the hero is mad at God because he's letting soldiers be killed in Iraq, that's an example of cosmic conflict. There may be no solution, but it's still a conflict.

- A man convicted of murder begs God's forgiveness to get into heaven.

Social Conflict. This is known as human *vs.* group conflict. The hero has a problem with an entire group of people who, collectively, play the role of the antagonist. The group does not need to be fully developed, only represented. In that case, the conflict is more like human *vs.* idea. Some examples of this are:

- The hero needs the cooperation of a group he is not fond of in order to complete his goal.
- The group doesn't like the hero and makes it hard for him to accomplish his goal.
- The hero must get a group of people to work together in order to accomplish *his* goal.

Other Issues of Conflict

Perception of Conflict. When it comes to conflict, the important thing is the character's *perception* of a problem, what his or her outlook on the situation might be. For example, imagine we're creating an end-of-the-world movie—but when Eddie, the main character, is informed that the world will end, he doesn't care. We have no conflict there. Eddie must care about the problem in order for it to create conflict. This can sometimes make it challenging to find the conflicts within our live-event stories.

Simultaneous Conflicts. There can also be more than one conflict going on within a single story. Imagine this scenario:

Jenny creates a start-up business in a town where she is unpopular.

Her parents are hassling her to get a real job.

Jenny must make X amount of dollars each month to pay her bills.

Which conflicts are present in these three sentences? Social conflict is the centerpiece because Jenny is not that popular in this town. Within this setting, she must get a group of people to buy a product from her in order to pay her rent. Inner conflict is created by her parents' pressure on her to get a real job—because Jenny cares very much about what her parents think. Those are two conflicts right there. We could easily add another sentence

o the story: "Jenny's ex-boyfriend smashes out the windows to her store, making her shut down for a day." Now, she also has relational conflict.

No Conflict? No Plot

It's very important to understand conflicts and how they work. Remember: if you have no conflict, you have no plot. We now have a pretty good understanding of the story and we will revisit some of these theories later in the book. Now, however, it is time to explore how the narrative elements are captured visually—what pieces we need to shoot to create our story. Everything we film is with the purpose of creating the story.

Concept Films

Concept films may not have plots, but they still have stories. Often, that story can be wrapped up in one word. For example, "light" could be the central theme of a concept film I created by assembling a series of cool shots of lights and then weaving them together in a crafty way. There's no plot, but in a sense there is still a story being told. The rule is, if your story cannot be described in one sentence, it is not a concept film.

2. Shot Sequencing

At this point, we are pretty knowledgeable about story structure. We know what to look for and think about when trying to create our story. We also know the elements of the plot that need to be present in order to tell a compelling story. Now, let's venture into what exactly we need to film. What shots need to be present to create these compelling moments? How do we break the story down?

Filmmakers Create a Story

There is a big difference between videography and filmmaking. The most important one is that in videography you capture what is happening as it happens—and you keep it as-is when presenting your final product. When you are filmmaking, on the other hand, you build your story piece by piece, shot by shot, and sound by sound to create the best story. This can be quite complicated. The story is out there in a million different pieces and it is your job to find the pieces you need, capture them, and put the story together.

We've already covered the structure of the story, so you know exactly what we're building up to. Now, though, we need to go all the way back to the beginning. We need to forget the overall story and focus on a single moment—one of many individual moments that, assembled back-to-back, will culminate in a complete story.

What shots need to be present to create these compelling moments?

We will call each of these single moments a "shot sequence." Shot sequences are the building blocks filmmakers use to tell the story and control the message. This is obviously the case in a movie, commercial, or other pre-planned story where we have control from the outset. However, even when we are not in control of what we're shooting (as when shooting a live event), we still control the message through shot sequenc-

ig. This leads us to two important concepts for filmmaking.

Forget About What Happened. You must drop your need to re-create the situation in front of you. For example, let's imagine that I'm making a film about a corporate event. I'm shooting a speech by the president of the company and using it as the undertone of the film. The speech is 2 hours long, but I have to cut it down to 5 minutes. If I decide that the end of his speech makes for a fantastic introduction to the film, guess what I'm going to do? Move it to the front. If I believe that rearranging his speech makes it better, then I don't care what happened in real life. You don't care anymore either. Do what is best for the film. Forget reality.

The Camera Is the Viewer. From here on out, you will treat the camera as the viewer. Where you place it, how you set it to expose, how you move it, and what lens you put on it are all choices that will affect the viewer's perception of your film. We'll go over camera movement later in the book (see chapter 5), but all the settings we'll talk about in that chapter relate back to this point.

Types of Shots

Every shot you have in a sequence will fall under one of four categories: a wide shot, a medium shot, a close-up, or B-roll. Let's define these and then talk about how to assemble them.

Wide Shots. The wide shot is very important in filmmaking. A big mistake people make when they discover interchangeable lenses is that they forget about taking wide shots. Wide shots, however, may be the most im-

Wide shots help set the scene for the coming action or interaction.

Wide shots may be the most important factor in making moments feel real.

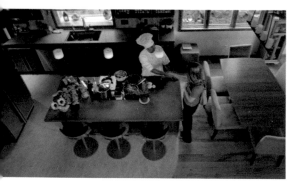

portant factor in making moments feel real. The purpose of a wide shot is to establish the setting and to overwhelm the viewer.

These shots can be very difficult to light and very expensive to create. If you are making a commercial and you want a big wide shot with 150 people filling the frame, I hope you budgeted for extras. If you are at a wedding, the work is done for you—and the fact that there *are* 150 people around in this single moment is an element that needs to be shown in your shot sequence. It changes the dynamic of the moment dramatically. Just the noise in the room will be largely elevated

as opposed to having 8 people in the same room). Every detail matters in making things feel real.

We've established that the camera is the viewer. But let's imagine, for a few seconds, a situation where the camera is *you*—and you've just walked into a crowded Best Buy store on Black Friday. What is your first instinct? You enter the store and you look around in awe. Look how many people are here! Look how much stuff is here! Maybe you stop and look around, maybe you keep moving toward your desired purchase, but either way, you are looking. No one walks into that situation with their head down. Think about what you see. You see everything all at once. Think about the speed at which your brain processes images. You can't focus on one single person or one single item from that front-door viewpoint. You just see it all and hear it all at the same time.

This is exactly what a wide shot is—it is everything at once. It makes the viewer feel as if they just walked into Best Buy on Black Friday. It is important to *show* them the hundreds of people that would be in the store. If you just showed them a shot of one woman buying a computer, then this could be Best Buy on any random Tuesday afternoon. See the difference? The overall sense of the place is what you are capturing with a wide shot.

That wide shot is your viewer's introduction to the room—or, in our case, the moment. It contains vital details for your story. It also contains details that have absolutely zero relevance to the story. It even contains details that will never be noticed. Showing those details that will never be noticed is what this is all about. It's the little things that make the wide shot important. You are showing the situation your characters are in (or will be in very shortly). Establishing where your characters are and what is going on around them is your biggest tool for making moments feel real. (You will also need to establish your light and sound; we will cover this in chapters 6 and 9.)

The medium shot is how we begin to single out our subject from that crowd.

Medium Shots. Think back to that wide shot in the busy Best Buy store on Black Friday. It is overwhelming to see all that activity—and, at this point, the film could be about any of the hundred people in the wide shot. The medium shot is how we begin to single out our subject from that crowd. The medium shot focuses on the subject, yet still maintains the view of a little activity going on around them.

The medium shot is the most commonly used shot in filmmaking—I like

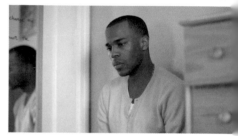

Take a look at some medium shots and absorb the visual. The medium shot is how we single out the subject.

to call it the "happy medium." If your shot sequence is assembled correctly, it should generally contain more medium shots than any other type of shot. Over the course of the film, each subject should be singled out several times with a medium shot.

Close-Ups. The close-up is the most powerful shot in filmmaking. It draws all of the viewer's attention to a specific thing, so a lot of movies reserve the close-up for an important line or facial expression. This is where

you will control the message you want the viewer to take away from that particular moment.

We will delve deeper into the close-up in the following pages, because it deserves its own section. Just keep this in mind when watching your next movie: If you see a close-up, chances are the filmmaker is trying to tell you something. That's just how you want to think when *you* are the filmmaker, too. If the audience needs to know something to move the story forward

n their mind, then it is time for a close-up.

Close-ups tend to be the most cinematic shots because of the lenses used to create them. Unfortunately, this sometimes causes people to over-use them, causing the close-up to lose its value and lack the required impact when you truly need it.

The B-Roll. B-roll shots are secondary footage that do not move the story forward. What you shoot for B-roll can fall under the category of wide, medium, and close-up—but if it is not part of your main sequence, it is B-roll.

B-roll is extremely important because it lets us get rid of unwanted content. People make mistakes when they talk—they pause, sniffle, cough, giggle, and do other things that, as filmmakers, we may find distracting. This is the case in both live-event film-making and staged filmmaking.

When you are covering a live event, B-roll is an absolutely essential part of

Take a look at a few close-ups. Remember that the eyes are the windows to the soul—and close-ups often show the character's eyes.

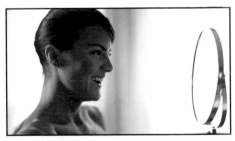
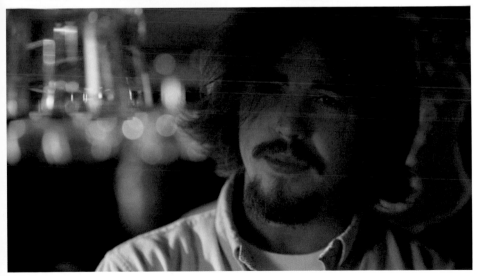

your success in making a seamless film. I would go as far as saying it is impossible without B-roll, because B-roll is what allows us to rearrange what *actually* happened without anyone picking up on the change. Here's an example. When filming a wide shot of the bride and groom getting married, I may

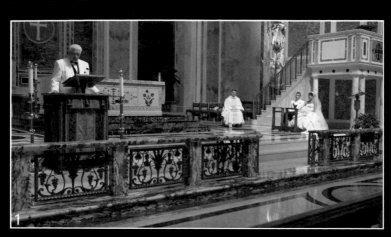

I filmed the wide shot (1), then ran up to get the close-up (3). It doesn't matter when I took the middle shot (2), so long as I have it. In editing, I placed the B-roll shot between the wide shot and the close-up.

decide to run in and shoot a close-up. That results in a shaky, out-of-focus section in the middle of my footage. Fortunately, that shot of the wedding party gazing at the altar, something I filmed 10 minutes before this, will nicely cover up the unusable footage. In my film, the final sequence (as shown on the facing page) starts out with a wide shot of the entire scene (1), cuts to the shot of the wedding party looking at the altar (2), then moves into the close-up of the bride and groom (3). Without the B-roll of the wedding party, it would have been very difficult to achieve that seamless transition.

When you are shooting a staged event, like a short film or a commercial, B-roll is also vital. Let's return to the Best Buy example and show you how that fits in. We start, again, with the overwhelming wide shot of the entire scene, followed by two medium shots. The first shot is of the customer and the second is of the Best Buy worker. It cuts back and forth between medium shots of the people talking when the Best Buy worker says, "Sale." Then we cut to a close-up of the customer's reaction. See how that moment was built? Without even looking at images you can vividly imagine the sequence.

Where does B-roll fit in with this equation? Well, during the series of alternating medium shots, a couple problematic things might happen:

1. The scene could start to get boring because the viewer is looking at the same two shots for a while—and that is never good.
2. The viewer may start to forget the surroundings in which the conversation is taking place.

B-roll solves both of these problems. Simply drop in a shot of a random person browsing the movie section. Does it mean anything? No. Does it move the story forward? No. It simply reminds us that we are in Best Buy on Black Friday and breaks up the repetitive feel of the two medium shots.

The Order of the Shots

So, we can use wide, medium, and close-up shots, but in what order should we place these shots? This is a question with no right or wrong answer. The thing to understand is that you can organize the shots in different orders to accomplish different things.

Wide, Medium, Close. Let's start with the standard order: wide, medium, then close-up. Starting out wide, then working your way in to the subject is very effective, easy, and used quite often. A lot of filmmakers like to start off with a wide shot because they really love to give the context of the moment. As I noted previously, I would go as far as to say that this is the most accurate representation of real life. We walk into a room and see

The standard shot order moves from wide (1), to medium (2), to close (3). Compare this with the shot sequence on the facing page.

der of these shots. When you open a sequence with a wide shot, you present it in an overwhelming manner. Instead, let's consider starting the moment off with two different close-ups of objects that are directly related to the moment. Showing these two close-ups with zero context makes the viewer attempt to figure out what they mean. The next shot, then, is that nice, big, wide shot—but because we inserted those two close-ups before it, we have dramatically changed how viewers now see the wide shot. Rather than just trying to take it all in, the viewer will be analyzing the wide shot, trying to find out where the close-ups were taken. In the process, they have no choice but to at least notice the moment and the context. Just by switching the order of the shots, we changed the way our viewers will perceive the moment.

Close-Ups in Context. Let's say you love the aforementioned style, which happens to be my artistic preference when making films. What should you show as close-ups? To decide this, you must step outside of the shot sequence and think about the big picture. This is what directing is: thinking about what happens in the first 30 seconds, and how it will affect the last 30 seconds. The major difference between the mind-set of a cinematographer and the mind-set of a director is that the cinematographer thinks in the moment while the

the whole setting. Then, we seek out our preferred destination in the room, which will most likely result in a medium view of whomever we end up talking to or looking at. The close-up is reserved for the fantasy-like view of the moment to which we want to draw attention.

Close, Close, Wide, Medium, Medium. Yes, we can make this quite complex when it comes to the or-

director is always focused on the big picture.

If you are making a shot sequence of a moment for the beginning of a story and you want to open it with a "close, close, close, wide" sequence, then your close-ups should show the "what" of the action. Show a few shots of what the character is doing—maybe something with his hands.

For example, let's say you're filming an 8-year-old trying to tie his shoe in the mall. The first close-up is of the shoe. That's followed by a close-up of his hands tying the shoe, then maybe one more close-up from a different angle, showing the hands tying the shoe. Next, we drop in the wide shot, showing the kid kneeling on the ground and tying his shoe as people walk around him.

Because we are at the very beginning of the story, it's important to show the action *before* the character. At this point in the story, the kid is meaningless; what he is doing is all we care about. If the first shot showed his face looking down, it would have no impact; we don't know who he is.

Now let's move this same shot sequence into the middle of the story. At this point, you might choose to start the sequence with a close-up of the child's facial expression to show his frustration, then a close-up of his hands tying the shoe. Finally, you could add the wide shot, showing the context of the moment.

Changing the shot order changes how viewers will perceive the moment.

Why can you show the child's face *first* in the exact same sequence? Well, we're now at a different place in the story. The character has been developed. We know him and have a connection to the boy. As a result, the simple fact that he is frustrated will invoke some type of emotion in us. At this point, the characters have meaning and the value of the story starts to shift away from "what" and into "who."

Pick a movie—any movie—and look for the work-in/work-out style.

Rearranging your shot sequences can have a dramatic effect on the way the viewer perceives the story. There is no fully right or wrong way. It is just important to know how to control every single aspect of your film so that you deliver the message you want to convey.

Shot Order and Flow. Some filmmakers use the order of shots to help with the flow of their film. For example, you start out wide and work your way in toward the subjects. As the moment ends, you work your way back out and end the same way you came in. This way, you start and end every moment on a wide shot. This helps with transitions.

Think about the camera being the viewer again. We know how we walk into rooms with a wide, overwhelming view, but how do we leave them? The exact same way. Think about that for a second: start wide (like walking into a room), move in close (concentrating on important elements of what is inside), and end the same way you came in (only with a better understanding of what happened). That's how real life works. So pick a movie—any movie—and as you watch it, look for the work-in/work-out style. You will see it more often than not. This is not an accident; it is to represent how viewers approach the real world.

3. The Art of the Close-Up

The close-up is the most powerful shot in film and there are many uses for it. It can be the difference-maker in the emotional tone of your film. Because the close-up has so much power, you can easily fall into the trap of overusing it. This will weaken the power of the close-up shots in your film.

Types of Close-Ups

There are a few different types of close-ups: the medium close-up (MCU), the close-up (CU), and the extreme close-up (ECU). Each one is more extreme than the previous. Look at the three images to the right and observe how each one is framed. Notice how no one is in the center of the frame.

Uses of Close-Ups

Filmmaking is all about details. The way we make situations feel real is by extracting and re-creating as many details as possible. The more details the viewer can experience about a specific moment, the more realistic it feels. As

A medium close-up (MCU) shot.

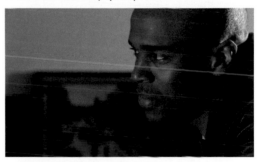

A close-up (CU) shot.

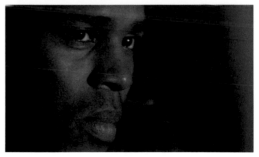

An extreme close-up (ECU) shot.

And How About Point of View?

If the camera is the viewer, and the bride says, "I do," where is the most emotional spot for the viewer to stand? It's where the groom is standing, as he is feeling all the emotion. Think about what he sees. Some could argue that it would be a medium view of the bride's face, but I think it's more likely that he's staring into her eyes and not focusing on anything else at that particular moment. (We'll look at point of view and camera placement in the next chapter; this is just a little foreshadowing!)

a result, there are a number of uses for the close-up, but they all lead back to controlling the message.

Identify the Character. A casual and common use for a close-up, as we've already discussed, is to tell the audience who the main characters are. A character will often get a close-up during their introduction so the audience makes a connection with them. Seeing a close-up of a character tells the viewer that they will most likely see this person reoccurring within the story.

Conversely, the lack of a close-up also says something. If there are five characters introduced in the opening scene but only one of them gets a close-up, the viewer will be able to discern that this is the main character. Another character may have screen time but not receive a close-up because there is no need to draw specific

attention to them. This ties in with the point about overusing the close-up. If you overuse it, the audience may become confused about your central message.

Emphasize Important Lines. One instance where I would use a close-up is on the most important line(s) of a moment. This draws attention to the lines and helps deliver the message in a more powerful manner. Action movies do this quite often with their one-liners, helping to draw attention to their significance.

If you are a live-event filmmaker—say, a wedding filmmaker—you might use the close-up on the bride's face as she says, "I do." Think about how much more *real* a close-up would feel than a wide shot of the whole scene. (You could also use a medium shot, which isn't a bad thing.)

Show the Reaction. An alternate use of the close-up is directly *after* the most important line—to show the character's reaction to the words.

Let's look at an example. Imagine that same bride from the previous example. I might film a medium shot of her saying "I do," then cut to a close-up of the groom cracking a smile of relief as a tear leaks from his eye. I could use a second close-up, this time of the bride bursting into tears, as the final shot. This would be a perfect example of how cutting to the close-up after the most important line, showing the reaction, would be more

ffective than holding a close-up the ntire time. If neither party happened o make the expressions I'm looking or, then I would go for the close-up on the lines spoken.

Some filmmakers believe that the facial expression has more power than any words. I agree with this to an extent, but it's a judgment call you have o make every time you step behind the camera. How good are the actors? Or are you filming real people in a real situation? Based on these factors, you can gauge their emotional output in the moment.

As Establishing Elements. Close-ups can also be used in an establishing role. While wide shots are vital for establishing the overall scene, there are times when you want to establish details of the scene that can't be revealed in a wide shot. (This is similar to how I described the use of B-roll footage in chapter 2. The only difference is that these close-ups help move the story forward, rather than just setting the scene.)

Let's take that same bride and groom at the altar getting married. We have 150 people in the audience, one priest, an organ player, a pianist, and we are in a church. What could we establish with close-ups to help strengthen the story? The first thing that comes to mind would be the parents of the bride and groom. That gives us four more shots to increase the variety of what we are seeing and introduce some secondary characters. Additionally, it helps bridge the gap between the emotion and a wider audience, which can dramatically change the way the story is viewed.

Our goal is to get the viewer to project themselves into the story through a character. If you only show the good-looking, young couple speaking their wedding vows, your emotional outreach is to good-looking, young people. Those are the people most likely to project themselves powerfully into those characters. When you add the four shots of the different parents to the story, you broaden your emotional outreach. You give the older generation characters they can project themselves into.

What could we establish with close-ups to help strengthen the story?

These four shots could be the difference between people viewing the story as bystanders and people feeling like they are directly in the room. Think about that. Your film could be just *four shots* short of amazing— but four shots short of amazing could be emotionally nonexistent. Remember this example as we move into the next chapter about point of view and perspective.

4. Perspective and Point of View

If you have yet to take a mental break, please do so before we delve into this chapter. Much of what we have covered will converge and start to make sense here. In this chapter, we will be covering where to put the camera and what lens should be used at any given time.

What to Show

Where you should put your camera is a highly (and possibly endlessly) debatable question. There are countless theories, styles, and preferences. I have developed a style based on some of my favorite filmmakers (like David Fincher), who tend to let their characters/subjects tell them where to put the camera. This does not mean your lead actor turns around and says, "Move the camera over there. It looks better." It means that you place your camera based on the point of view you want to capture. In this decision, you factor in where the characters are looking, what they are looking at, and from whose point of view the story is being told.

Trust the Viewfinder, Not Your Eyes. On many sets, I have heard someone (usually someone who had absolutely no clue what they were talking about) blurt out, "Oh—check this shot out! It looks cool from over here." This is an incredibly frustrating thing to hear as a filmmaker. It's impossible to make useful suggestions about where to place the camera without looking through the viewfinder and understanding the true dynamic of the moment.

Place your camera based on the point of view you want to capture.

The last time I checked, people have *two* eyes; the camera just has just *one*. What *we* see and what our *camera* perceives are two very different things. We walk around in a 3-D world; in filmmaking, we compress that world into a flat, 2-D image. Through camera movement and light-

ng (see chapters 5 and 6), we can try to bring back as much of the 3-D feel as possible—but to truly understand perspective, we need to stop seeing things with our eyes. We need to train our minds to see the way the *lens* sees. Refer to the following equation:

cinematic viewpoint +
character's perspective +
desired audience viewpoint +
lens selection +
rules of cinematic perspective
= your ideal shot

Don't worry if this seems confusing at the moment. We'll look at how it works—and by the end of the chapter, you should be able to make these calculations quickly.

The Camera Is the Viewer. Again, the camera is the viewer. When calculating where to place the camera in any given moment, we must ask ourselves what we want the viewer to perceive. The answer should account for two components:

1. What is the most cinematic and most emotional viewpoint?
2. Who do I want the viewer to be on this particular shot?

In chapter 8, we will cover types of narratives and points of view from which to tell your story—and this will address the second part of the answer. For now, let's focus on the first point,

the cinematic/emotional viewpoint. We'll consider a close-up as an example. As mentioned earlier, the close-up helps the viewer connect with the subject. Since it is used sparingly, it has impact when we do use it. Let's work with the generic logic that the closer we are in film, as in life, the more intense the conversation feels. What is the opposite? Maybe we choose *never* to show a close-up because we want the audience to feel a disconnection with the character at that specific moment. Do you see how that works? Our distance from the subject affects our perception of the moment. Now, let's dig deeper.

Our distance from the subject affects our perception of the moment.

What the Character Sees. There is a rule I like to follow—and by "rule" I do not mean I do this 100 percent of the time, but it happens to be a very good guideline for a "when in doubt" situation. My rule goes as follows:

If I show a character, whether in a close-up or a medium shot, the next obvious shot is to show what he or she is looking at.

Films are all about anticipation. We anticipate the climax and the end-

ing. Your big anticipatory moments will get all the credit, but anticipation does not always have to be conveyed on a large scale. Actually, if you can achieve it on a *small* scale, your film will feel all the more intense. You can create anticipation simply by showing a person's facial expression. In their expression, it should be obvious that whatever they are seeing makes them feel a certain way. Right there is a moment of anticipation—the audience is practically begging you to reveal what this character is looking at. (Once they see what the character is looking at, the jig is up. It's time to move on to other sequences.)

A good filmmaker uses the camera angle to achieve an emotional response.

By following this rule, you are letting your characters tell you what to shoot. If they look at something, or someone, you show it. When practicing this theory, you will want to keep in mind the point of view from which your story is being told in that moment and overall. You can show the viewpoints of secondary characters at any given moment, but you want the overall emphasis to remain on the main character's point of view.

The cycle of anticipation and revelation we just discussed consisted of two shots—and two shots could equal 5 seconds. If you had those moments of anticipation occur every 20 seconds, your film would be an emotional masterpiece.

Camera Angles

Camera angles are not chosen based on how cool they look. It may seem this way at times, but a good filmmaker uses the camera angle to achieve a desired emotional response. If you come to filmmaking from a still photography background, you'll find a major difference in the approach. While the photographer chooses the camera angle to make the subject look as good as possible, the filmmaker chooses the camera angle to convey an emotion.

High-Angle Shot. Let's begin with the high-angle shot. In still photography, when we shoot down on a subject it makes them look smaller or thinner. This is the greatest aid in making a heavier bride look more trim. Or there is my case—where I was trying to rent a house in a nice neighborhood with a 90-pound pit bull as my pet. The landlord asked to see a photo of my dog in order to finalize the deal. So I climbed on a ladder with a 24mm lens and shot down on my ridiculously large dog. All of a sudden, my 90-pound pit bull looked like a 30-pound dog of an indistinguishable breed. The lease was signed the next day. Shooting from that high

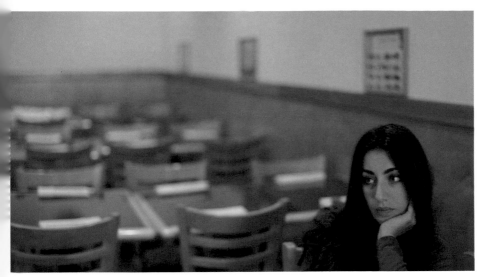

For this shot, I paired a high angle with the emptiness of the room behind her to give you a sense that the subject is vulnerable.

angle made him look far less threatening—and that's exactly how we use the high-angle shot in filmmaking. We don't pick it necessarily to make our subject look *smaller*, but to make them look more *vulnerable*. Shooting down on a subject makes them less intimidating. If a scene requires you to show a power difference between two subjects, you should shoot down on the subject who is supposed to be vulnerable in the situation.

Showing vulnerability is not the sole usage of the high-angle shot, of course. Let me paint you a picture. Two people are having a conversation. One person is standing at the bottom of the stairs and the other person is at the top of the stairs. Using our rule about point of view, we'd want to show what the character would

see. To show the point of view of the character at the top of the stairs, that means you would need to shoot down on the person at the bottom of the stairs—so the angle makes sense.

Shooting down on a subject makes them less intimidating.

You may be asking yourself in this situation, "Is my subject going to be perceived as vulnerable just because he's standing at the bottom of the stairs?" In this case, I think that the point of view rule would override what the high angle implies. However, if you have control over where the subjects stand, you might avoid

having them talk from opposite ends of the stairway unless you were trying to achieve that imbalance-of-power effect.

Using a low camera angle puts your subject in a position of power.

But maybe you *are* trying to show that character is more powerful than the other—in which case, putting them on stairs is a great way to do so. In fact, when you see a movie scene that contains this situation, more often than not the person at the top of the stairs is talking down to the person at the bottom of the stairs. And I do not mean "down" in terms of the direction; one character is actually belittling the other. Frequently, the scene ends with the person at the top of the stairs walking off in disgust and the person at the bottom of the stairs left standing there, pondering what happened. In these situations, the filmmaker is taking advantage of both usages of the high camera angle.

Low-Angle Shot. If a high camera angle makes the subject seem vulnerable, then it stands to reason that a low camera angle does just the opposite. Using a low camera angle puts your subject in a position of power. However, as still photographers know, shooting up on a person also makes them appear heavier. If a man is in front of your camera, that may not be a problem. If a woman is in front of your camera, you want to be careful.

The camera was at a slightly lowered angle to signify this character's dominance over the person with whom he is talking.

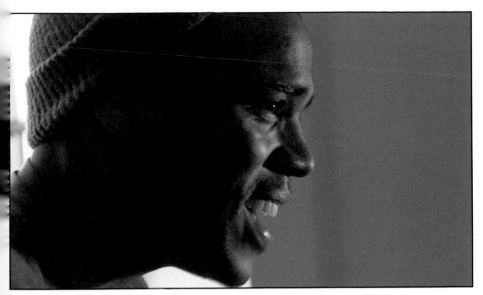
The camera was just above his eyes to make this shot.

Taking away from the beauty of a female can reduce her power, completely defeating the purpose of shooting up toward her.

There is nothing more to the low-angle shot than making your subject look powerful. Unless that is your desired effect, I would avoid the low-angle shot or look for a happy balance.

Eye-Level Shot. The eye-level shot has little to no psychological effect on the viewer. This will be your most used angle, especially when shooting a narrative film. Therefore, it is utterly important to get these shots right; otherwise, all of your other shots will lose their effect. Keeping a level of normalcy to your shooting style means that when you choose to shoot from a different angle (for the desired effect), the viewer will notice.

To keep the eye-level look while minimizing subject distortion, the height of your camera needs to change depending on the type of shot you are creating. For a medium shot, you will keep the camera at your eye level to achieve the eye-level look. For a full-length body shot, however, you will want the camera closer to waist height, splitting the difference in the length of the body (any lower would be a low-angle shot, and having it any higher would distort the lower body). For a close-up of the face, you would want to shoot from just above eye level.

Point-of-View Shot. The point of view shot is basically a first-person perspective that puts the viewer right in one character's shoes. How often you use this technique will be based on the

type of narrative you are telling (more on that in chapter 8) and your style. If you watch a hundred movies from a hundred different filmmakers, you will see a wide variance in how much this technique is used. Some filmmakers frown upon it; others believe this is the key to making your audience connect with the character.

When you are finished reading this section, pop in *The Social Network* and watch the opening scene. It is a 9-minute conversation between two people. During this conversation, you see a wide two-shot (putting two characters in the frame at the same time). You will also see medium shots of each character and close-ups of each character. The medium and the close-up shots are initially filmed from a two-thirds view, but toward the end of the conversation the view switches to straight-on close-ups of each character. This is an example of the point-of-view shot. Director David Fincher chose to use this angle

Show the character (1), then show what they see (2).

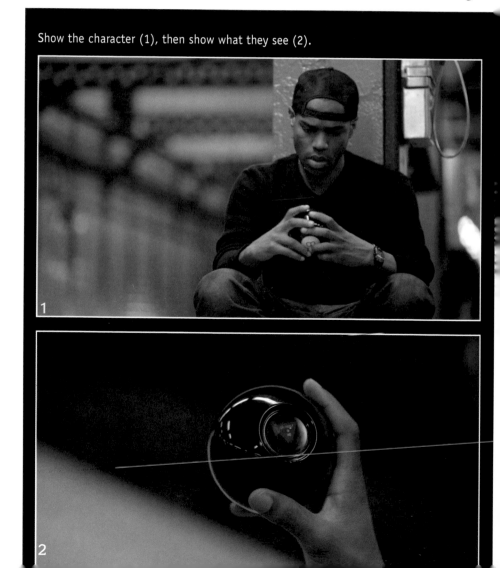

This is an example of a bird's-eye view that would be practical on a small budget.

for specific lines. He wanted you to *be* these characters, to see what they see and feel what they feel, at this specific moment. In the rest of the scene, he wanted you to be an observer of the moment. Do you see how the camera angle can dramatically change your view of the moment?

If there is a moment in your film at which you feel it is imperative for the audience to feel like a certain character, then the point-of-view shot is one way to make this happen. Some of the critics of this style, however, say that it is a cheap way to put the audience in the character's shoes.

Bird's-Eye Angle. For the bird's-eye view, you will need a helicopter, a crane, or a very tall ladder to show the audience an overhead view of the entire scene. Many movies use this for establishing shots that scream "pro-

duction value!" If you can get one of these in your film, I would highly recommend doing so. It is a great scene-setter, and most audiences can recognize the setting with this type of shot.

Worm's-Eye Angle. The worm's-eye view is the opposite of the bird's-eye view. It is a very low shot —from the ground, looking up to the scene. I would reserve this shot for films featuring children or animals as characters. For these projects, the very low angle shows the way the small char-

An Unusual Example

I suggested watching the opening scene from *The Social Network* to demonstrate the point-of-view shot because it's a somewhat unique example. It is uncommon to jump to the point-of-view shot in the middle of a scene where it has yet to be used. I often use the point-of-view shot, but I use it the entire way through a scene, telling the viewer to focus on one character.

acters view the world. So if you want the audience to feel like the toddler in your film for a shot or two, it is extremely effective to put the camera at his or her eye level.

Dutch Angle. Using a Dutch angle simply means tilting your camera to one side or the other. This creates a feeling of disorientation in your shot.

The 180 Rule

Now sit back and get ready for one of the only "rules" I definitely recommend you follow: the 180 rule. The world exists in a 360 degree arc all around the characters, but your camera's view should be from just one side of that circle. This rule is based on where the characters are looking (facing), not so much on where they are standing or where they will be moving. Let's look at a series of images (facing page) to see how this works.

How the Concept Works. The first image (**1**) is a two-shot. Notice that character one is on the left side of the frame (facing right) and character two is on the right side of the frame (facing left). This establishing shot reveals where characters are standing and—more importantly—where they are facing.

As we go deeper into this shot sequence, we will obviously add medium shots and close-ups that show only one character. Let's move over to our second shot (**2**)—a medium-close-up of character one. Notice he is still on the left side of the frame and facing to the right. No matter what type of shot you dream up, he will always stay there. Some people, myself included,

The camera's angle and distance to the subject(s) can change, but it should remain on one side of the 180 degree line.

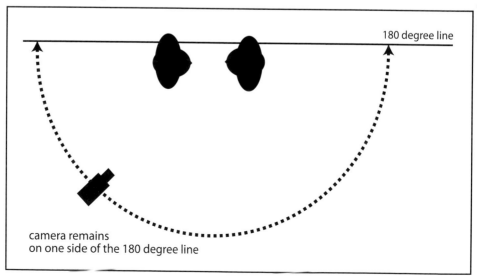

180 degree line

camera remains
on one side of the 180 degree line

A two-shot establishes where the characters are facing. Character one is on the left side of the frame, facing right.

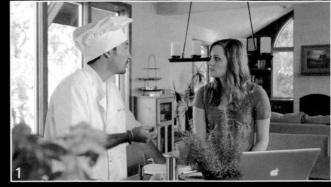

In this medium close-up, character one remains on the left side of the frame, facing right.

As we move even closer, character one stays on the left side of the frame, facing right.

like to leave the other character's shoulder (or the back of their head) in the negative space of the shot to fill the frame, as seen here.

If we move on to the third image (**3**), the close-up, nothing changes.

Character one stays on the left side of the frame, facing right. That negative space we are leaving open represents the other character.

If you have a similar shot with character two, you can cut back and forth

Controlling Negative Space

In this shot, notice how character one is almost completely on the right side of the screen. He is still facing right, but the shot looks extremely awkward because the negative space (representing the other character) is on the "wrong" side. It is standard practice to have people look across the negative space (as in the previous two images), but we can use this angle to produce a desired effect—it's not as uncommon as you might think.

If I had included this shot in the previous sequence, it wouldn't have broken the 180 degree rule . . . but it would have looked awkward. This is a good reminder to base your framing decision on where the character is facing, not just where he's standing.

between the two shots in the final film. This makes it feel like the characters are close together, increasing the intensity of the scene. Such a strategy would be very effective for wedding filmmakers to implement during the wedding vows.

Implying Movement. What happens when you cross the line? Well,

let's focus on one character riding a bike from 1st Street to 85th Street. It is important to the story that we get him there, but you cannot have your actor actually ride his bike 85 blocks while you follow him in a car with your camera. (Well, you *could*—but your audience may kill you for forcing them to watch something so boring.) The simple solution is to cut down the ride significantly. This requires the use of establishing shots (like street signs) to tell the audience what street he is on. We also need some way to imply movement. Fortunately, viewers have been conditioned since the dawn of filmmaking to understand visual cues about movement. However, you must stick to the 180 degree rule.

Here's what I'd do. I start my character on the left side of the frame and he takes off riding his bike toward the right side of the frame. For this one shot, I follow him as he rides from 1st Street to 2nd Street. Then, I let him completely exit from the right side of the frame on the wide shot. Next, I might cut to a medium shot of him riding the bike—but I have to make sure the rider, once again, enters from the left side of the frame. He will always enter from the left and exit to the right. This makes it feel as if the frames are connected in some way. If he were to exit right on one shot and then *enter* right on the next shot, it would feel as if he had turned around and was now riding in a completely

different direction. Breaking the 180 rule can cause the viewer to become disoriented.

Oh—and did you notice that we are on 43rd Street now? Neither did the audience. When they do finally notice that 41 streets have been skipped, they will think nothing of it. They will have inferred that movement from the split second where the character was entering and exiting the frame.

Cat in the Window. Let's say you are a rebel—you are the guy who breaks all the rules. One way to break the 180 rule is with a "cat in the window" shot. This is a non-character shot that breaks the conversation for a moment. So, say you have a dialogue scene in which you have established your characters on their respective sides of the frame. Now, however, you want one or both of them to cross the frame. To do this, you'd add a "cat in the window" transitional shot. Then, you can come back in with the characters on the other side(s) of the frame. You are just breaking the conversation for a moment. The result should look like the image sequence to the right.

In this sequence, the image of the food in the pan (4) is the "cat in the window" shot. It breaks up the established character positions (1–3), so you can come back to them from a different perspective (5–6) without confusing the viewer.

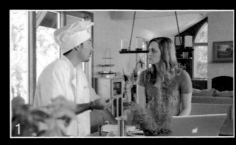

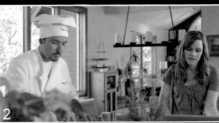

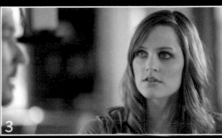

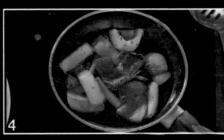

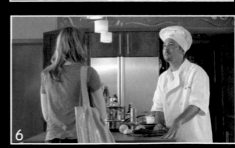

In this sequence of two-shots, we can move from one side of the characters (1) to the other (2) without confusing the viewer. The characters' relative positions remain clear.

The other way to break the 180 rule is not really breaking the rule, since the characters remain in a clear relationship to one another. Let's focus on a two-shot. We use this type of shot to show characters and where they are standing in relation to each other. However, if you wanted to cut to the opposite side of the line from two-shot (1) to two-shot (2), you are more than welcome to do so—and it won't confuse your viewers.

Lens Selection

When it comes to perspective, the final ingredient is lens selection. We will go through a handful of lenses and look at which ones are good for specific shots. I will use the Canon L-series lenses for this, but you can apply the same concepts to any lens line-up you wish.

Sensor Size. My examples will all be based on using a camera with a full-frame sensor. If your camera has a smaller sensor, multiply the focal length of the lens (in millimeters) by the crop factor to determine the effective focal length of the lens on your camera.

A cropped sensor is too small to record the entire image area that the lens is projecting, so lenses will all give slightly more telephoto views than on a camera with a full-frame sensor. For example, when you have a 35mm lens on a full-frame camera, that 35mm angle of view is exactly what you see. If you move the same 35mm lens to a camera with a sensor that has a 1.6 crop factor, you'll get something closer to a 50mm angle of view (35mm x 1.6 = 56mm).

A cropped sensor is not better or worse than a full-frame sensor. You just need to understand the size of your sensor to prevent miscalculating your composition.

Aperture. Before delving into focal lengths, I want to mention the maximum aperture on these lenses.

Focusing

Shooting wide open can make focusing very difficult, especially for live-event filmmakers. Please note that the chapter on how to focus is not coming. If there were a chapter on focusing it would consist of one word: *practice*.

The 5D has a full-frame sensor, whereas the 60D has a 1.6 crop factor. For these examples, the cameras were side by side, taking the same images. Notice the focal-length adjustment needed to retain the same composition. Also, note that the depth of field for the 5D is always much shallower.

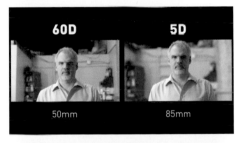

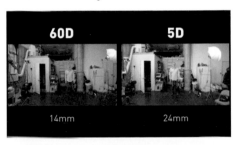

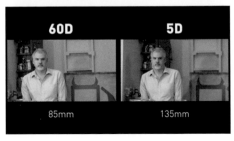

Most of the L-series lenses have an f/1.2, f/1.4, or other insanely wide maximum aperture that allows you to record a very shallow depth of field. I like that look, but just because your lens *can* shoot at f/1.2 does not mean you *should* shoot wide open all the time. Pick a movie off your shelf—any

movie. Do you see the shallow depth of field constantly throughout the entire movie? No. It is used sparingly. Take your cue from Hollywood: when it makes sense to use it, do so. There is no need to abuse the look.

14mm, f/2.8 Lens. The 14mm is a wide-angle lens—very wide—mak-

The wide view of Canon's 14mm, f/2.8 lens makes it an obvious choice when shooting scene-setters like those seen here.

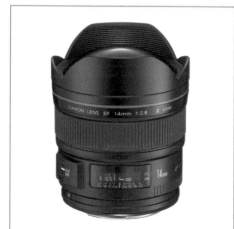

ng it your best choice for establishing shots. It is also incredibly sharp, another reason it's good for wide scene-setters. These shots rarely have a single focal point; instead, everything is shown in focus. On this lens, the hyperfocal distance is just 3 feet, so everything more than 3 feet from the camera is in focus. (I am not going to attempt to explain the physics/mathematics behind hyperfocus. If you are bored at work one day, Google it. Trust me, you will regret it!)

Suffice it to say that this short hyperfocal distance allows for some interesting choices. First off, it makes this lens the obvious choice for establishing shots and bird's-eye views. Second (and more importantly), it makes this the lens of choice when operating a Steadicam. We will cover camera movement in the next chapter—but, for now, imagine trying to walk without shaking the camera *while* focusing it. It's not going to happen. The sharpness of the 14mm is your best bet there.

There are also some things to avoid with this lens. First and foremost, do not stick it in anyone's face. If you are trying to make a close-up with a 14mm lens, you and your subject will both be very unhappy with the results. When we talk about the 35mm lens, I will show you how to use a wide-angle lens for a close-up—but the 14mm lens is not going to serve you well for this purpose.

There is nothing amazing about this image except that, because he's near the edge of a frame shot with the 14mm lens, the 180-pound subject looks like he weighs about 250 pounds. Compare this to the previous images of him on page 49.

Additionally, on cameras with full-frame sensors, the 14mm lens can actually be *too* wide. The sides of the frame become warped as a result. To combat this, you could switch to a camera with a cropped sensor. Alternately, you could plan on scaling into the image during the editing process. This requires careful attention when shooting, since anything at the immediate edge of the frame will be scaled out of the final shot. The third option is to use the distortion for effect. I use a combination of all three approaches. I happen to really love the 14mm lens on a full-frame camera—but you have to be careful not to put a human near the edge of the frame. They will look "large and in charge" (and potentially hate you forever).

24mm, f/1.4 Lens. The 24mm is a wide-angle lens with a hyperfo-

cal distance of 10 feet (so you can see why the 14mm becomes so valuable when you need to shoot on the move). Like the 14mm, the 24mm is a wide lens—but I think of it more in terms of "wide background." You can absolutely use the 24mm for a wide-angle shot if you don't have a 14mm, but I would never intentionally choose the 24mm over the 14mm in that situation.

Where the 24mm lens becomes unique is in the f-stop department. The 14mm is an f/2.8 lens, whereas the 24mm is an f/1.4 lens. This means that the depth of field can be much shallower on the 24mm lens.

I use this lens to shoot sharp close-ups of objects and medium views of people against a very wide, out-of-focus background. For example, if I wanted to keep the focus on a character crossing the street while including the feel of a busy city in the background, I would use the 24mm lens. Accordingly, this is the only lens where the rule about avoiding the largest aperture does not apply; if I am using this lens specifically to achieve the looks mentioned, it's in my best interest to shoot at f/1.4 or very close to it.

Also, keep in mind that you will see edge distortion when using this lens on a full-frame sensor. It will be far less dramatic than with the 14mm

Canon's 24mm, f/1.4 lens is a good option for a "wide background" shot (bottom). The wide maximum aperture of this lens also gives a shallow depth of field that works well for close-ups of objects (below, left).

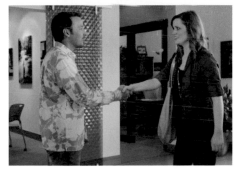

Canon's 35mm, f/1.4 lens replicates the view of the human eye, making it a good choice for two-shots and medium shots.

lens, but it's still quite apparent—especially when filming people.

35mm, f/1.4 Lens. The 35mm lens can do it all—and it's my favorite, most-used lens. It can be a wide-angle lens. It could be the best lens for two-shots. It can also be used in circumstances where you'll be moving the camera. (If you are an event film-maker, this lens is the easiest to run around with, creating cinematic shots without too much trouble focusing.) In Hollywood movies, this lens is the most common choice for medium shots of characters. I think filmmakers and cinematographers are drawn to it

Canon's 50mm, f/1.2 lens is great for filming people.

because it replicates, to a great degree, the view we see of a scene with our eyes.

The fact that this lens mimics the view of the human eye so well also makes it a great choice for point-of-view shots. If you stick a 35mm lens in someone's face, you will undoubtedly distort them. The distortion will not be a distraction, though (as it is with the 14mm lens)—it's just noticeable enough to be used for a desired effect. I find myself calling on the 35mm for a point-of-view close-up when I want the audience to feel like the character is "up close and personal."

Another great feature of this lens is that it is the last wide-angle lens before we start to transition into the telephoto lenses. Therefore, it retains the sharpness of a wide-angle lens, but it also starts to give the depth of field of a telephoto lens. I would go so far as to say that if you could only have one prime lens for your cropped-sensor body, the 35mm would be the best choice.

50mm, f/1.2 Lens. The 50mm lens is the best in the game; it's everything the 35mm is, just better. I find myself using this lens, more than any other, when filming dialogue. In other words, this lens is great with people. It has a very sharp look. It shows enough background to give context, but not so much as to be distracting.

This lens is also a good choice for the rack-focus (or pull-focus) tech-

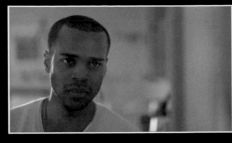

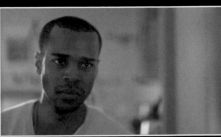

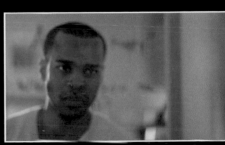

An example of the rack-focus technique with a 50mm, f/1.2 lens.

nique, where you change the focal point of your shot from one subject to the other. With the 50mm lens, the change in focus will be very dramatic.

85mm, f/1.2 Lens. As far as the Canon L-series is concerned (I cannot speak for any other brand), I think the 85mm has the best look of them all. A good friend of mine rightly describes this as the "can't miss" lens—unless, of course, you miss the focus.

Now, if you are an event filmmaker, you're not going to find a lot of uses for this lens. Running and gunning with the 85mm can be problematic. First of all, it is very heavy and makes your camera front-heavy. Additionally, focusing on the fly will be a huge challenge—even for a wizard.

However, let's say you are making a short film or a commercial. In that case, this is your money lens. When you are in complete control of the scene, the 85mm is one that should be used often. It will take your work to another level. I find myself using this a lot when I am making a movie. In fact, I cannot think of a better lens for close-ups.

When working in controlled situations, Canon's 85mm, f/1.2 lens is ideal for close-up shots.

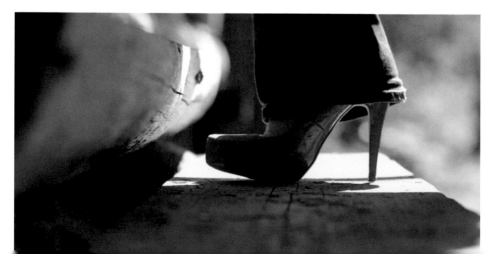

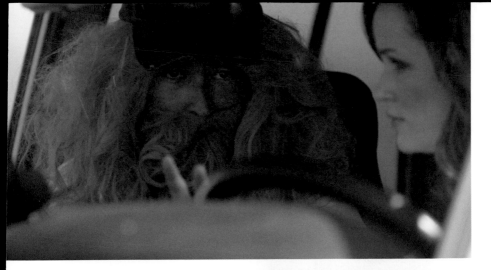

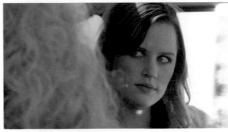

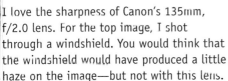

I love the sharpness of Canon's 135mm, f/2.0 lens. For the top image, I shot through a windshield. You would think that the windshield would have produced a little haze on the image—but not with this lens.

135mm, f/2.0 Lens. This lens is as sharp as they come. At first I stayed away from it; I had the focal points covered in some of my other lenses and never thought I needed it. One day, I was on a shoot and forgot my 85mm. Fortunately, a nice young lady who was finishing a photography ses-

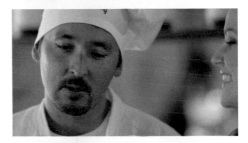

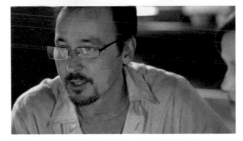

sion loaned me her 135mm lens for one shot—a full-length view of a character in a subway. I was about 60 feet from the subject and I had the camera

on a dolly. I was happy with the shot and thought nothing of it—I thanked the helpful photographer and she went on her way. About six months later, however, I saw the edited scene. I asked my editor, "What kind of color correction is on this?" He reminded me that this was a rough cut and I'd be doing all the color. Then I remembered: it was that 135mm lens! What an interesting look it creates.

There is something about the sharpness of the lens that makes me really favor it in certain situations. In theory, you could use this lens in place of the 85mm. It is lighter, easier to focus, and a little sharper in my opinion. However, I would recommend having both. If it is a question of budget, the 135mm lens is about half the price and offers most of the same qualities.

180mm (Macro), f/3.5 Lens. Whether for live events or staged shoots, every filmmaker needs a macro lens—a lens that lets you fill up the entire frame with a small object. This could be vital in the storytelling process, as there is commonly a need to draw the viewers' attention to some object within the story. In fact, I can't think of a project where this lens was *not* utilized. Its results are something that cannot be duplicated with another lens.

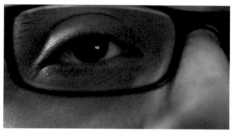

Some macro images created with the Canon 180mm, f/3.5 lens.

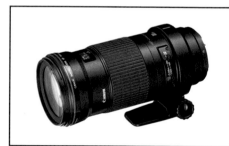

5. Camera Movement

Camera movement is where filmmaking goes pro. Many filmmakers understand that camera movement exists and know its benefits as far as eye-candy is concerned. Some of them even know the different types of movements—and maybe even how to create them. However, understanding which camera movement to use in a given situation is what really separates the film students from the pros. While camera movement alone doesn't create emotion (the story does that), picking the right camera movement can make or break the emotional output of your scene.

Camera Movement and the Impact of 3-D

Camera movement is a huge aid in making a film feel real and dimensional. In real life, when you walk around this earth, foreground and background objects cross each other in your field of view—and your brain processes it as a normal occurrence. It is such a normal occurrence, in fact, that you are probably asking yourself, "Why did he just mention that?"

Here's why: this is the single hardest point of translation from what we see in the real world to how we depict the world in film.

The latest obsession with 3-D movies is all based on making a flat, 2-D medium feel more like the real world. On this topic, there is a big split among today's great filmmakers. James Cameron (director of *Titanic* and *Avatar*) preaches that 3-D is the future. Conversely, and in the same generation, you have Christopher Nolan (director of *The Dark Knight*) boycotting 3-D and saying IMAX is the way.

In no way, shape, or form am I *ever* going to say anything bad about James Cameron—he is likely the most innovative (and certainly the highest

Is Movement Required?

Let me just make an additional point before we get into the meat of this topic: you do not need camera movement to make films. There are plenty of films that use camera movement sparingly and they are great works of art. However, I believe camera movement is the best way to take viewers out of their seats and make them a part of the action.

grossing) filmmaker in history—but I'm with the Christopher Nolans of the world. To me, 3-D changes the whole art of cinema. When you rely, at least in part, on camera movement to make things feel real, there's an art to picking the right movement at the right time. When shooting 3-D, those decisions become less important, because everything is already "real."

So, for the next few pages we will assume 3-D is impossible—or that you cannot afford to do it. We will use the art of camera movement to make things pop off the screen.

One More Time: The Camera Is the Viewer

Not to sound like a broken record, but I must say this one more time: the camera is the viewer. This means that the lens selection, the camera position, and how we decide to move the camera is going to have a drastic effect

The rule of thirds grid provides a framework for more interesting compositions.

A variety of compositions based on the rule of thirds.

on the viewer's experience. Let's break down each movement and describe some different situations where it would be useful.

Composition

The first thing to cover is actually not moving the camera at all. This will be your most used movement (or lack thereof). The stable shot relies strictly on composition, a concept that also has an effect on how the camera moves and how the movement is perceived.

The Rule of Thirds. Above is a series of screen shots showing different types of compositions. They are all unique, but the one thing they all have in common is that they follow the rule of thirds. Whether you are shooting a close-up, a medium shot,

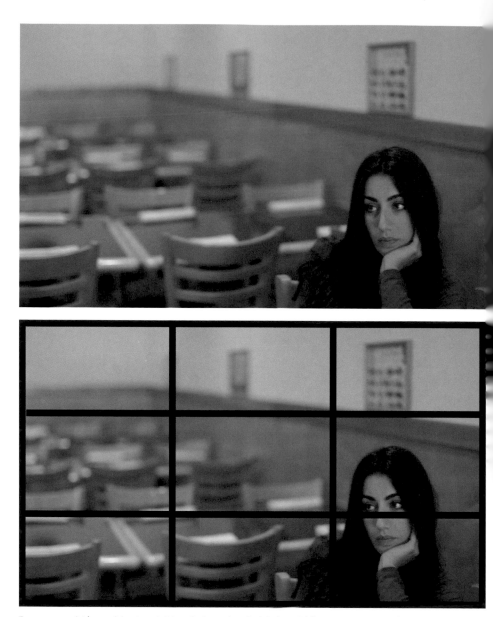

I composed the subject outside of the rule of thirds grid because I wanted to make her appear isolated in a large field of negative space.

or a wide shot, the rule of thirds is important.

According to the rule of thirds, you divide the image into nine equal parts using two equally spaced horizontal lines and two equally spaced vertical lines (like a tic-tac-toe grid). Placing your subject along one of those imaginary lines or at the intersection of two lines creates more tension, energy, and interest in your image than just placing the subject in the center of the frame. Most cameras provide a grid option on the LCD screen that helps guide you when framing your shots.

Composition ties in with camera movement because it is often your goal to work within the grid as the camera moves. In fact, there are camera movements where the whole technique is to hold your subject's position within the grid.

Filling the Frame. There are a lot of cinematographers who believe that filling the frame is a priority. However, there are also times when we frame shots differently for a desired effect. Look at the images on the facing page. Notice how the subject is framed into the bottom right of the grid, leaving a ton of negative space above and to the left. I left the negative space on purpose so that I could show how isolated the character is.

The way you decide to compose your shot will have a big effect on how your story is perceived. So, by all means, be creative with your framing.

Now, let's start to move the camera just a little bit.

Pan and Tilt

Tripod and Fluid Head. In filmmaking, having absolute control of your camera is crucial, so a good tripod is a must. To start, I recommend getting a set of Manfrotto 755XB tripod legs and a Manfrotto 502 fluid head.

The two most basic and important movements we will discuss are the

Manfrotto's 502 fluid head.

The Manfrotto 755XB tripod.

pan and the tilt. THEY CANNOT BE DONE WITHOUT A FLUID HEAD. There is a reason that was the first all-caps sentence in this entire book. A fluid head is critical in this equation—it does all of the work for you. Human imperfection is cool in hand-made dishes, but not in pans or tilts.

The fluid head works off a re-sistance measure. The 502 has an adjustable knob for the pan (on the left side of the head) and one for the tilt (under the quick-release plate). These control the resistance, which is adjustable to seven levels. When you pull your fluid head out of the box, you need to memorize the strength of your pan/tilt movements with your arm. You will move it *the same way every time* and adjust the resistance to determine the desired speed for your camera movement. (In other words, you do not move it harder to get a faster movement or more gently to get a slower movement.)

Human imperfection is cool in hand-made dishes, but not in pans or tilts.

Panning. The pan is simple; just push or pull your hand in a horizontal direction. There are a few ways and reasons you would want to do this. Let's break them down.

Follow Movement. If your subject is moving, you may need to follow him/her. Panning is one way you could follow the movement. You have seen this so many times in movies that you barely notice when it happens. Fol-lowing movement is something that will happen quite often. We use it for many purposes, whether we are telling our actors to move, or we are trying to capture movement at a live event.

Introduce a New Subject. While you have your camera framed on one sub-ject, there could be another subject, off screen, that you need to bring into the frame. To do this, pan left or pan right—pick your poison—to bring them into the scene.

Add Movement. When filming a scene that could take place with stable, well-composed shots (no movement), you *could* choose to pan in a number of shots. When edited together, the series of panned shots creates a great look. I was never a huge fan of this approach until the cinematographer for *A Happy Ending*, my third feature, implemented it in a scene and I fell in love with it. At the right time, with the right shots, it is very effective.

The Quick Pan. For this transitional movement you pan the camera quickly to the right at the end of one scene, then you pan into the next shot (in the final sequence of the film) from the same direction. When you put those two shots together on the edit-ing board, it looks like one seamless

hot. This is great for scene-to-scene transitions, but you have to know which two shots will go together before editing. When you start pre-planning these transitions, you've reached a more advanced level of filmmaking.

Tilting. Tilting takes our camera movement to the vertical axis. It's a far less common movement, but still vital to the process of filmmaking. I view it more as a transitional movement than anything, but it can also be used for some of the same things as panning.

Follow Movement. Vertical movement is not quite as common as horizontal movement—but hey, sometimes we do film airplanes, right? If you need to follow movement from up to down (or down to up), the tilt is the way to go.

Transitional Movement. An effective and common way to introduce a scene is to tilt down from the sky. This is usually done with a wide-angle lens to exude a scene-setting feel. If you do not have access to a helicopter for that bird's-eye view, then tilting down to the scene is a worthy substitute. Conversely, tilting up (and possibly panning away) is a great way to exit a scene.

If you keep this kind of shot in mind as you watch some of your favorite movies, you will see the tilt-in or tilt-out movement quite a bit—but not every time. It has a lot to do with the flow of the film. Sometimes,

Cranes/Jibs

Do you really need a crane/jib? The short answer is no. You do not need much to be a filmmaker these days. However, a decent 12-foot crane is about $500. To me, that seems like a small price to pay for the ability to do some very professional movements and achieve a high production value. This does not mean you have to drop everything and buy a crane, but you should consider putting that cost in next year's budget. The crane offers you a step up from tilting into a scene—more like what you see in the movies. In my opinion, it is a professional look you can add to your films at a very affordable price. You will not use it often, but when you do it will step your game up a few levels.

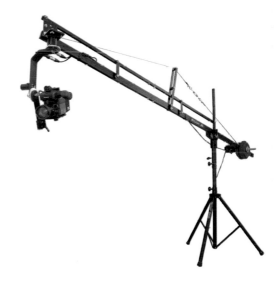

Using a jib offers a step up from the tilt-in movement.

scenes cut from one to the next with no time for the viewer to digest them. So when a scene is particularly dramatic, intense, or important, the tilt is a way to give closure and allow the viewer a moment to process what just happened. It is a judgment call you have to make every time.

During a tilt-in, you will often hear audio from the scene that is about to happen. Again, this is a great way to walk the viewer slowly into the setting. Imagine, for example, the camera tilts down into a scene while you hear a voice-over—a DJ promoting a song on the radio. Again, ask yourself if it's helpful to give the viewer a second

A shoulder mount lets you add a controlled, hand-held movement.

to get caught up in the scene. If so, tilting in may help you control the emotion of the moment.

The Fly on the Wall

We've all thought, "I wish I could be a fly on the wall in that room." But have you actually considered what that means? As a filmmaker you have the ability to put your viewer, as an unseen observer, right in the room with your characters. In a way, this is our entire goal as filmmakers.

A Human Feeling. The fly-on-the-wall look is designed to simulate someone's first-person view. Remember the point-of-view shot we covered in chapter 4? The way to make that shot look as realistic as possible is to add some movement. Think about

ow we, as humans, walk around the world. We are constantly moving. We move our heads, we move our eyes, we rock, we shake—there is no such thing as being perfectly still. In film, the fly-on-the-wall look uses subtle, controlled movement to simulate that feeling.

Shoulder Mounts. What we want is a hand-held look, but that does not mean that you should actually hand-hold the camera or walk around. In fact, let me take this opportunity to say you should *never* hand-hold the camera. There should always be some type of device aiding you.

For a fly-on-the-wall shot, the best choice is a shoulder mount. These are available from many manufacturers, but I really love the Cinevate products. Just get one; you will need it for this equation. Put a telephoto lens on your camera, lock in on your subject using the rule of thirds, and then try to hold frame. Let's say you are filming two people talking and your camera is on one of them. Because people move when they talk, the small movement needed for you to hold frame on that subject will create the fly-on-the-wall look. You will never be able to hold frame perfectly, no matter how good you are. That's the point; human imperfection is the art of this movement.

This is my absolute favorite camera movement. One reason is that it is so good at simulating what we see in the

Required Viewing

Fly-on-the-Wall Shots

Movie to watch: *The Hurt Locker* (2008)
What to keep in mind: This is a great example of how well the fly-on-the-wall approach works. The camera is a little more shaky than normal, but you will see why. Think about the concept of intensity mimicking intensity. This film could be a textbook on just that concept.

real world. The other reason is that it gives you the best control over the intensity of the scene. Intensity mimics intensity—and movement is the best way to exploit that. If I am locked in on a subject and trying to hold frame as they casually have a conversation, my camera is mimicking their casual movements. What happens if the conversation heats up and they start yelling? They move more—and when they move more, my camera has to move more, too, in order to hold frame.

There is a popular misconception about using a shoulder mount; people think you walk around with it. You can, but the device is actually designed to produce the fly-on-the-wall look. Another great use for the shoulder mount is by broadcast videographers in transition to DSLR shooting; with it, you can make your rig feel like the big beta cameras that you are used to.

A dolly allows you to move the camera smoothly along a straight or curved line.

Mobility also becomes easier with the shoulder mount. You can be recording a clip, see something 60 feet away, then run over and grab the shot. (You are not recording the running part, though—you just have the ability to get where you need to be more quickly than if you were shooting from a tripod.)

Tracking Shots

The dolly (or slider) shot is simply a mechanically smooth movement in either direction, along a straight or curved line. It's an impressive look—and one that beginning filmmakers tend to lean on heavily. It's a bit like when you had your first drink and you were just an annoying sort of tipsy. The dolly can make a filmmaker behave the same way. It is easy to overuse.

The Dolly. If you are a DSLR person, I would recommend a Cinevate dolly, which will get you to about 4 feet. If you need or want something a lot longer, take a look at Kessler for a 50- to 100-foot track. Preemptively, let me just save you the time and

trouble of attempting to build your own. It seems like a simple design that you could easily make with a tile cutter, a skateboard, or some other contraption. But I have tried them all and can tell you this: they never work well. Save yourself some time and money and buy one.

Type of Shots. There are a number of options when it comes to using this type of camera movement. Let's go over them all and discuss good applications—so you can avoid becoming the guy who uses the dolly in *every* shot just because just because he owns one.

Let me save you the time and trouble of attempting to build your own . . .

Straight Dolly Shot. Straight dolly shots are simple; just send your dolly from right to left (or vice versa). You can follow a subject, introduce a new subject, or just dolly across a subject or scene. You are going to want to

have a wide-angle lens on; anything from the 14mm to the 35mm will work just fine for a shot like this.

Curved Dolly Shot. If your track has the ability to curve, then this, too, is a no-brainer. Set up the curve and let the track do the work. If you only have a straight track, you can still use a simple camera trick to simulate the look of a curved dolly shot. Start with the camera on one side of the dolly, turned in toward the subject (in the direction you are planning to move). As you dolly, pan in the opposite direction of your movement. When you reach the end of the track, your camera should be pointed in the opposite direction from where you started. The combination of dolly and panning movements creates the sense of a curved path.

Dolly In. To create the look, dolly in toward your subject while simultaneously pulling focus (or use the 14mm lens's hyperfocal distance to your advantage and don't worry about

As you dolly, pan in the opposite direction of your movement.

focus). In films, this movement is often used when a character is in deep thought. If you pull it off at the right moment, you'll look like a genius. There is a way to simulate this in editing (by scaling into your subject), but it's much less effective.

Dolly Out. Dolly away from your subject. There are many uses for this,

Panning as you move your camera along a straight dolly track simulates the look of a curved track.

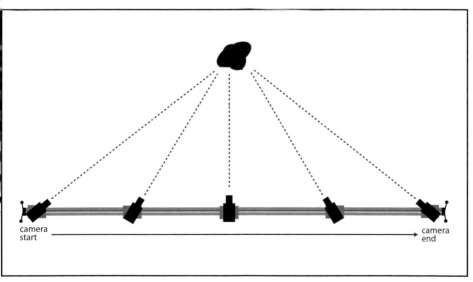

camera
start

camera
end

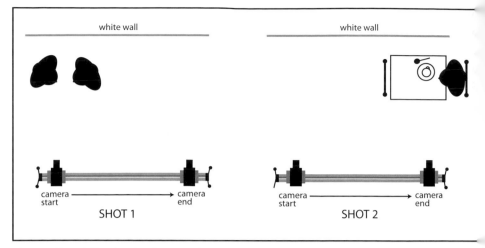

The tracking dolly shot is often used as a scene transition.

but in most cases it is associated with a negative emotion and usually takes place at the end of a scene.

Vertigo (Push/Pull) Effect. The vertigo effect (named for Alfred Hitchcock's popularization of it in the film *Vertigo*) is a look you see only in the highest level of production. To create it, you dolly away from your subject while simultaneously zooming in. This keeps the subject at a consistent size in the frame, but it makes the background look as though it is rushing forward. It's a very interesting look that has a huge impact on how the viewer perceives the character. (Think "falling away from oneself"—that's the sensation you are creating for the viewer.)

The look gives a very unrealistic perception of depth, so it is best reserved for surreal moments. It is not something to overuse, but if you find

that moment in your film where you can implement this technique, do it.

Telephoto Lens on the Dolly. Since the invention of the slider, filmmakers have been placing the dolly on the ground with a wide-angle lens and illustrating all the movement in the foreground. This is not a bad look— but too much of *anything* is a bad thing. I have started, instead, using telephoto lenses in dolly shots. This switches the emphasis of the movement from the foreground to the background. It is essentially the same effect but it gives a completely different look.

Tracking Dolly Shot. The tracking dolly shot will be used quite a bit. When I think of this movement, I just think "smooth." This type of shot is often used as a scene transition. It is the same concept as a quick pan, only you will dolly into, let's say, a white

wall. At the end of the shot, the white wall should fill the entire frame. Then you start your next shot with a white wall filling the frame and dolly away from the blank white space. When you place these two shots end-to-end in editing, it feels like you have one seamless shot. Films should feel seamless when we watch them, and any little technique that contributes to the fluid feel is going to help. I always carry a black piece of cardboard with me. If there is no object to dolly away from or into, I just have an assistant hold the black cardboard at the end of my shot.

Steadicam

When it comes to camera movement, the Steadicam is the mother of them all. It is the most expensive and it takes the most practice to master. Do not expect to order your $4500 Steadicam from Tiffen and be able to use it right out of the box. That will *not* happen. It takes a lot of practice—in fact, I suggest watching many tutorials before you even attempt to use it. The rig is designed to isolate the camera from your body, so the trick to the Steadicam is balancing the weight evenly. The best advice I can give you is just to walk normally and let the rig do the work for you.

The Steadicam isolates the camera from your body, allowing for complete freedom of movement as you shoot.

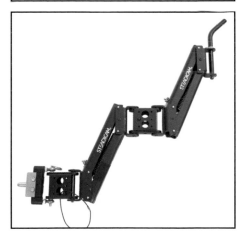

Steadicam Shots

Movie to watch: *Goodfellas* (1990)
What to keep in mind: Get on your
computer and Google *"Goodfellas
Steadicam shot."* Watch it and you'll
see why we use it as *the* example of
the power of the Steadicam shot.

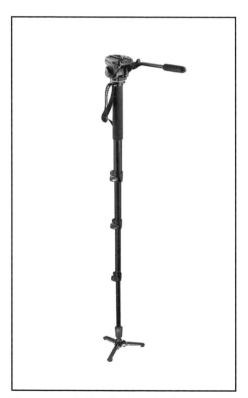

The monopod (detailed on the facing page)
is an important piece of gear for live-event
and feature filmmakers alike.

We use this movement to follow
characters through the scene. The idea
is that the camera can go anywhere
and do anything, all with free range
of motion. You should even be able
to walk up and down stairs with the
camera and have it be smooth.

You can avoid the need for this
type of shot by leaving your characters
stationary, but taking a conversation
on the move makes the production a
lot more complex. When characters
walk, it gives the illusion that the story
is moving forward. This is extremely
important; the story always needs to
feel as though it's advancing.

A Final Thought

My last thought on camera move-
ment is to stick to the idea that your
camera's movement should mimic
the intensity of the moment and the
movement of the subject. As a film-
maker, you want to put together the
whole package when it comes to using
camera movement on the screen in a
justified fashion. This is your biggest
tool for turning 2-D images into 3-D
experiences for the viewer.

So, What Do I *Really* Need?

Most of you reading this are not gearing up for a feature film production—and if you are, you probably lack the $50,000 you could spend on all these devices to stabilize/move your camera. So, the question at hand is this: What do I buy? The following is what I recommend (and the order in which I suggest adding these devices to your filmmaking arsenal).

1. Monopod

If most of your filmmaking is going to be at live events (run-and-gun shooting), a monopod is a must. Even for the feature filmmakers, though, I should point out that over half the shots in my last film were shot using a $300 monopod (Manfrotto 561 BHDV). (*Note:* If you do not do *any* live-event filmmaking whatsoever, you'll probably want to make a tripod your first purchase; this is covered later in the chapter; see section 3.)

The Pros
- Small, versatile, mobile. Can simulate almost every camera movement.
- Comes with a detachable fluid head.
- You become very nonthreatening with this setup. You could film in Grand Central Station without getting caught. (But please do *not* do that!)

The Cons
- If you remove the monopod's fluid head and attach it to another device, it will not pan. All the panning happens at the bottom of the monopod.
- It should not be left standing up by itself. You can do it, but it is absolutely not recommended.

2. The Dolly/Slider

Whether you are buying an Atlas 10, Atlas 30, or the Pegasus, the slider is the second piece of gear you should buy. It will raise the production value of your films immensely. We are entering expensive territory here, but when you add this tool to your kit, you become more valuable. In other words, it pays for itself.

The Pros

- Using a dolly/slider raises production value.
- It gives you the ability to do tracking shots.
- Your work is (at least in theory) more valuable, so you can charge more.
- The Cinevate sliders are all-terrain. You can bring them anywhere.
- The Atlas 10 can mount to a single tripod. All the other sliders can mount to two light stands, giving you the ability to control their height.
- The Pegasus has a removable table dolly so you can do tracking shots on any flat surface. You can also skew the wheels for curved dolly shots.
- Sliders are easy to travel with. They fit in a light-stand bag.

The Cons

- Does not come with a fluid head—and you *will* need one.
- Can be on the more expensive side of the gear collection.
- It can be tempting to overuse the dolly, resulting in less plausible looks.

3. Tripod

You need one. I would tell you this is the first thing you should buy, were it not for the monopod. However, if you are not doing any sort of live-event filmmaking, then the tripod *is* the first thing you should buy.

The Pros

- You can walk away from the camera and your composition stays right where you left it.
- Very stable.
- Easy to travel with.
- You can level the camera even if you are not on a flat surface.

The Cons

- Limited in the movements you can make.
- Can be quite bulky (compared to a monopod, for example).
- Not very mobile.

4. Shoulder Mount

The next thing you should buy is a shoulder mount. To truly create the point-of-view look, you should accept no substitute. I know it is fourth on the list, but it

s still very important to the filmmaking process. Shoulder mounts are available at all different price ranges, so pick one up—even if it is on the cheaper end.

The Pros

- The king of the fly-on-the-wall look.
- Makes you very mobile.
- Easy transition for videographers to become filmmakers.
- Easy to travel with.
- Free range of motion. Turn from your waist to pan.

The Cons

- Limited use.
- Cannot walk around and expect a smooth shot.
- Can be expensive, depending on how elaborate your setup is.
- The height can only be as tall as you are, and you have to be careful about the angle you get.

5. Steadicam

If you want to be at the high end of filmmaking, you want one of these. There is nothing like just being able to walk anywhere with your camera and not have to worry about it shaking all over the place. This gives you many options when it comes to filming.

The Pros

- Free range of motion.
- Highest production value.
- Gives the story the feeling of moving forward.
- Can create the fly on-the-wall look.

The Cons

- If you do not practice, you cannot operate it well—and your footage will look terrible.
- Very expensive.
- Once you are set up, it is not easy to switch to another piece of gear. The best thing to do in a live event is dedicate a camera to just the Steadicam.
- Obtrusive.

6 Car Mount

There is a company called Delkin that makes a $90 car mount called the Fat Gecko. For the price and utility, it is a no-brainer to acquire one of these. The uses are endless.

The Pros
- You can do car-mount shots with a professional look.
- Helps mimic subject movement. Once it is mounted to something, it takes on the life of the object.
- Very easy to use.
- It does the work for you while you film from another angle.

The Cons
- It is a heart-throbbing moment (and one you just have to get over) when your expensive camera is mounted to a car going 70mph.

7 Crane

If you want something that adds production value, the crane is pretty cheap for the value it brings—even if it's not something you're likely to use very often.

The Pros
- High production value.
- Cheap.
- Easy to mount to a tripod.
- Very durable.

The Cons
- Very bulky and difficult to travel with.
- Counterbalance weights are a separate purchase from the crane.
- You will need to purchase a fluid head.
- Not used all that much.

6. Lighting, Color, and Exposure

The Power of Lighting

In live-event filmmaking, there is often not too much you can do in regard to the lighting (aside from thanking the tech-heads for giving us the ability to shoot at higher ISOs than ever before). When you can control the light, however, you should. In fact, you should *want* to control the light—you'll be ignoring one of your best tools for controlling the mood if you don't.

It is no secret that light has a direct effect on our mood. Even in real life, people control the mood with light. Think about movie night in your living room. Dim the light and set up the fireplace and the mood is just right. Candlelight is popular for a romantic outing with your significant other. Restaurant owners are obsessed with lighting their dining areas to reflect the perfect mood.

Lighting takes the most effort in the filmmaking process, which is the reason a lot of people simply skip this step. New filmmakers struggle with the idea of lighting so much that you

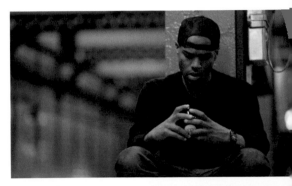

Compare these two shots and notice how the lighting suits the setting and helps set the mood.

will see a lot of "one-light shoots" going on. I am not saying you can't do anything with just one light . . . but if there *is* anything, it's not much.

This is where you still photographers making the transition into film-

Use a Light Meter

Selecting your ISO in combination with your f-stop to get the perfect exposure is critically important. You *never* want to overexpose an image (unless it is on purpose and for effect). If you overexpose your shot by even half a stop, chances are you will never be able to correct it in postproduction. This is why a light meter is indispensable when it comes to lighting and exposing correctly. Additionally, on a shoot that takes place over the course of two or three days, you need to re-create the identical light *each day*. You cannot have two differently exposed clips from the same scene next to each other in your commercial or film and expect it not to jar the viewer. I also use the light meter to measure the difference in exposure for different parts of the scene or even the difference between the shadow and highlight sides of the face. The light meter I recommend is the Sekonic L-308DC. This is a dual-purpose light meter. It has every photography function we know and love but it adds cinema functions as well. You can plug in your frame rate, for example, and see how it affects your exposure.

making have a huge advantage. You already understand how to manipulate light to create your desired look. However, as we'll see, for filmmaking your lighting approach must change somewhat.

Camera Controls

We need to start our look at lighting by considering some camera settings that will directly affect everything we do with lighting. Some of the settings we will cover apply to every camera; some are specific to shooting films with a DSLR. The most important thing to understand about all these settings is how they work together to produce the look you are going for. If you do not understand how to use these settings by the end of the section, read it again. There is no way you will be able to control the light without knowing how to control these settings.

ISO Setting. Before anything else, it is time to completely remove the word "automatic" from your vocabulary. There is no such thing as "auto" in filmmaking. You don't want your ISO setting to shift around as the camera tries to find the right setting every time the light changes. (In the absolute perfect situation, you might be able to get away with it, but I would never recommend it.) It takes minutes for your eyes to adjust to lighting changes, but it takes the camera only a second—so this approach will never result in a realistic translation. It will make your work look like home videos, not films.

The bad news is there is no ISO setting I can tell you right now that you could use as a rule of thumb. The boundaries of how high you can and should go depend on the camera. For each model, there is a setting I would never pass unless I was in a situation

where I had absolutely no choice. For example, on a Canon 5D Mark II, I would not exceed ISO 2500. On the Canon 60D, I'd stay at or under ISO 600. With a Canon 1DX, on the other hand, I'd shoot at up to ISO 10,000.

Many people believe that shooting at the lowest-possible ISO is the way to go. It is definitely not a bad rule to live by, but don't become a zealot. I rarely shoot at 100 ISO—for a variety of reasons. For example, remember when we talked about lenses and I said that just because you *can* shoot at f/1.2 does not mean you *should*? Since today's cameras can go to higher ISOs with no problem, changing the ISO setting will be one of your few tools when stopping down. From a purely creative standpoint, I often shoot at ISO 800 to add a little grain to my work. This helps me get the film look I always desire.

There is also a theory out there about the "native" ISO settings—160, 320, 640, and so forth—which are derived from analog gain rather than digital exposure compensation. I am not saying this is not real, but, personally, I have never seen a difference. By scientific measures, this may be accurate, but the human eye will not notice the difference. If you want to follow the rule, then more power to you. However, if you are in the middle of an open field and you need to be at ISO 100, I would not suggest

you automatically go to 160 ISO because of a pretty much inconsequential rule.

Frame Rate and Shutter Speed. The rule of thumb is to shoot everything at 24 frames per second (fps). This is the cinema standard and it's what our minds have been conditioned to perceive as cinematic. (And 24fps is actually 23.976fps—so just in case you ever see that setting anywhere, it means the same thing. It's just easier to say 24fps.)

I often shoot at ISO 800 to add a little grain to my work.

On television, the frame rate we see is 29.97fps. I would stay away from this frame rate unless your client requests it, or if you want to use it for artistic purposes. What would be an artistic reason to use the 29.97fps

Be sure to select the proper frame rate for your project.

rate? Say you have a character using a handy-cam and you wanted to show the actual footage from that camera. A great way to give the footage some distinction to the viewer is to shoot at a different frame rate. This is a situation that is seldom used, of course, so I would stick with 24fps.

> # There is an old rule that your shutter speed should be double your frame rate.

If you are planning a slow-motion shot, you want to shoot at the highest frame rate possible, which is usually 60fps. The more frames you have, the smoother the motion will be when slowed down in postproduction. But there's a trade-off: the more frames you have, the more light you will need. (For the sake of this book remaining current, let me just add this: 5 to 10 years from now, 48fps will be the standard. You heard it here first.)

Frame rate and shutter speed are directly related to each other, and they also affect the ISO. When it comes to cinema, there is an old rule that your shutter speed should be double your frame rate. So if you are shooting at 24fps, then your shutter speed should be $1/48$ second; if you are shooting at 60fps then your shutter speed is $1/120$ second. This is a rule of thumb, but it's far from unbreakable. When is a good time to break the rule? One case would be when there is a lot of movement among your subjects. Say you are making a film of what is happening at a basketball game. During the game play, choosing a faster shutter speed will help capture the rapid movements better on a digital camera. However, there is nothing wrong with sticking to the rule all the time.

Justify The Light

The need to justify your light is the biggest difference between lighting as a photographer and lighting as a filmmaker. In photography, the viewer doesn't have to understand the lighting in an image. In film, the light has to make sense. Let's think about an example.

Find the Light. You are shooting a subject standing in a dark field on a pitch-black night, so your goal is to successfully portray just that: a subject in a dark field. That means you want it to be dark. Being able to see the absolute finest detail in the subject's face, or having light in his eyes, would be totally unrealistic. Think about what would happen if your viewer walked into the scene. What would they see? They certainly would not be able to see his face, so if you set up a big light in the scene and shine it on your subject's face, it would be unrealistic and distracting.

That said, you cannot leave the scene unlit. You have to create *some*

Lighting Outdoors

One of the biggest misconceptions that new filmmakers have is that shooting outside is easier because lighting is never a problem. That is 100 percent false. Outdoors is actually the hardest place to shoot because you have very little control. No matter what kind of light you have, you cannot compete with the sun. That means you are pretty much restricted to adapting the existing light with reflectors, Scrim Jims, and ND (neutral density) filters.

Reflectors. A reflector is a simple tool that can be used to bounce light into

This image was shot under a porch. Adding a Scrim Jim (with ND mesh) cut down the trees behind her by 2 stops, making the two exposure levels match.

areas where it's needed to create accents or open up shadow areas that may be too dark.

Scrim Jim. I recommend the Westcott Scrim Jim, which comes in a variety of sizes and includes a reflector, a light diffuser, and neutral-density (ND) mesh. The mesh goes behind the subject to cut down the amount of light by 2 stops, enough to let you expose the subject and the background properly. This is your best lighting tool when shooting outside (it can also be useful inside).

ND Filters. When shooting outside, adding ND filters is just about the only way to stick to the $^1/_{50}$ second shutter-speed rule (twice the frame rate). I have found the Tiffen variable ND filter is the most useful. This cuts the exposure by anywhere from 1 to 8 stops, letting me shoot outside with the proper shutter speed, a fairly low f-stop, and a mid-range ISO. I recommend getting one or two of these if you find yourself shooting outside a lot.

sort of light to give the scene depth, but your challenge will be to remain within the confines of the real world. Look up and tell me what you see. Exactly, the moon. The moon is where the very small amount of available light is coming from.

Enhance the Light Realistically. That makes it your job to join in and enhance the moonlight. What does

this mean? The color of your light must mimic the moon. The strength of your light does not have to match, but it needs to be close enough to blend in with the moonlight. You will also need your light to come from relatively the same direction as the moon.

Consider Showing the Light Source. Light justification is about

enhancing the real-world light. Therefore, in the previous scenario, it would be a good idea to actually *show* the moon in your shot sequence—just to remind the audience where the light is coming from. On the other hand, if you were shooting in a restaurant (or somewhere the origin of the light was obvious), you might not need to show the source.

I constantly move objects and people through the scene . . .

In my last film, there was a scene where the subject was lit through a bunch of random holes cut in a sheet of poster board. The light beams hitting my subject looked super cool—but very unrealistic. To justify the lighting, I used a wide establishing shot at the beginning of the scene, then cut to a close-up of a boarded-up window that was peppered with bullet holes. With that single shot, I turned that creative lighting into something that made sense to my viewer. Justifying your light usually happens in a wide shot. If the light is especially unusual, as in the example above, you may want to show it in a medium or close-up shot to clearly illustrate the point.

Cheating the Light

Cheating is big in filmmaking. If a situation is not working for you, cheat anything and everything (outside the viewer's sight) in order to get the results you want. I constantly move objects and people through the scene to achieve my desired results.

The biggest thing you will cheat is the light. Keeping light justification in mind at all times, moving the light 5 feet to the left will not stop the light from making sense. If you can achieve the look you want on a subject by moving your light 5 feet this way or 10 feet that way, it is in your best interest to do so.

The image sequence on the facing page is a good example of cheating the light. In the first image (1), I justified my light by showing an out-of-focus exit sign behind the subject. I put the light in the shot, so it is now part of the scene. In the next images (2, 3), however, you will notice that the red light is significantly stronger. This is because, in the close-up and medium shots, I used a light with a red gel to enhance the natural light in the room. During the flow of the scene, the change in intensity will go unnoticed. Only when the scene is stopped does this "cheat" become obvious.

FACING PAGE—Showing the red light in the first shot establishes its place in the scene.

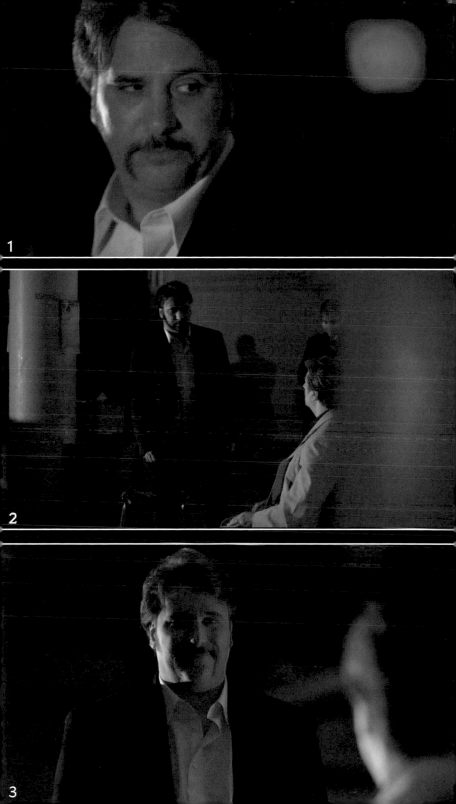

Shadows

Shadows are a huge part of lighting when it comes to filmmaking. In still photography, the shadows are controlled and never move. In film, however, the shadows are constantly in motion. This is something we always need to keep in mind. You could spend two hours telling your subject to sit still while you create the perfect shadows on their face—but as soon as the scene starts and they move, the shadows will be nowhere near what you wanted. There are two types of shadows we need to be conscious of: the shadows on the subject and the shadows the subject creates on the background (or on other subjects).

Another major concern is how the light hits the subject's eyes.

Shadows on the Subject. As far as shadows on people are concerned, if it makes sense to create a specific lighting pattern on a subject, and if it fits the lighting scheme you need for that given scene, it is never a bad thing. Having said that, I would never demand that every subject have a loop shadow below their nose; it will never happen on a consistent basis.

Lighting that makes sense generally wins out over classic lighting patterns. This is not to suggest you should never try to get the lighting pattern you want, or move the subject to a spot where you could justify the existence of a desired lighting pattern. However, a lot of times, the lighting setup that needs to be created will leave you with unconventional lighting patterns on the subject's face. There is a significant difference between perfect lighting and real lighting.

Another major concern is how the light hits the subject's eyes. As in still photography, getting light on the eyes (eliminating the "raccoon eyes" look) is a big concern. However, there are times when the lighting setup makes it impossible. If you find yourself in a situation where the lighting is set exactly how you want it, but the subject has no light in their eyes, that can still be okay. It is purely a judgment call. We need to keep reminding ourselves that "real" is our number-one concern. While raccoon eyes in photography are just wrong, in a film they can be used to produce a creepy, mysterious effect.

Therefore, I would never look at raccoon eyes as "wrong" in a film unless the effect made no sense. For example, if (because you had no lights and no reflector) your subject appeared with raccoon eyes in a sunlit outdoor scene, that would be incorrect—and just plain lazy. Adding a simple reflector to the scene solves the problem and is, of course, the correct move in that situation. Conversely,

f the subject was walking through a dark house lit only by random windows, intermittent shadows on the eyes would look real and correct. Do not let your inner portrait photographer make you lose sight of what is possible within the world of filmmaking. We do not always have light on our eyes in the real world, so why would the subject be given this unrealistic advantage?

Shadows Cast by the Subject. Now let's move on to the shadows that your subjects will create themselves. There is a popular misconception that your subject should never cast a shadow on the wall behind him. Again, though, we're looking for reality, and shadows are very much real. The reason to avoid letting your subjects cast shadows is that it suggests that there are lights on them. Indeed, if your light is in a place where it is unjustified then, of course, the subject's shadow *is* going to be jarring to the viewer and take them out of the story. If, however, your light is in a position where it makes sense, then the shadow will make sense, too. This sometimes means that the subjects will cast shadows on each other. If you always stick with the lighting setup that makes sense, then your shadows will always fall right in line.

Lighting the Mood

My pet peeve, with lighting, is when things are over-lit. You cannot just

Lighting for Effect

Of course, cinematic lighting isn't always realistic/justified. You can probably think of movie scenes where the lighting made absolutely no sense—scenes where it looked like some kind of fantasy. This is absolutely okay. However, if do you *not* justify the light, the scene and the effect should be over the top. The audience should know there is something unique about this scene.

light up everything brightly and have no contrast from scene to scene. Light has a direct effect on mood, and you want the viewer to experience something of an emotional roller-coaster ride. If every scene is *lit* the same way, every scene will likely *feel* the same way. Let the scene tell you how to

Another major concern is how the light hits the subject's eyes.

light it. If it is a happy conversation, then bright lights or a daytime setting makes sense. If it is a conversation about something darker, it should be lit darker. My personal style is dark. I love to light scenes in a very dark, contrasting way with lots of deep shadows and maybe shoot a little underexposed. I usually justify this by

1

showing the dim light sources in the room.

A Particular Challenge

Some of the hardest scenes to light are those shot in a bedroom at night. Watch a few movies where there is a conversation taking place in bed at night. See what the filmmakers do with the light. In most situations they have a whiter-looking light shining in through the window, trying to simulate a street lamp.

Above and on the facing page is a sequence of images from my last film, which had a nighttime scene in a bedroom. I wanted to use an amber color of light, to suit the actual conversation, but we only had one light source. Take a look at how we did it. The bed lamp is our light source and the lighting is justified.

ABOVE AND FACING PAGE—In the first shot (1), we rack focus from the picture taped to the desk lamp to the subjects. The desk lamp is clearly giving an amber glow. The next image (2) is the end of the previous shot. Notice how most of the image is in shadow and there are just small beams of light shining across the subjects. From another angle (3), the light is a little stronger on the female subject because she is physically closer to the light source in the scene. In the wide shot (4), which was never used in the film, you can see that the desk lamp is the light source. In the other shots, this lamp was gelled orange to get the desired color.

2

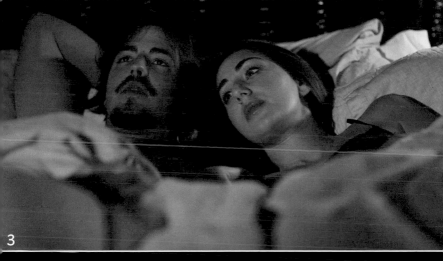

3

4

1

Lighting Color

Lighting color alone cannot give you a desired effect, it can only enhance what is there. Different colors of lighting can communicate a variety of different ideas, so how the audience will interpret any given color depends on the feel of your scene.

Red. An overall red tint is usually produced using a combination of red gels on the lights and an overall red increase during postproduction.

When I think of using red in a film, I think *evil*. It is a symbol of guilt, sin, passion, and anger. Quite often, it is associated with blood or sex. Satan is associated with red. Caught "red handed" is a common phrase. So, this color is associated with many negative emotions—but the color alone cannot send this message. Other elements

ABOVE AND FACING PAGE—In this two-shot (1), notice that the red is only on one character's side. Red means evil—and here the red is only touching one character (2). At the beginning of the scene, the good character is lit with yellow light (3), showing his good intentions in the moment. Notice that no red light is touching him. At the end of the scene (4), notice the red highlight on his face. Observe his facial expression. He knows he has accepted evil—and so does the audience.

need to be present in the scene for the red to have much effect.

Flip back a few pages and look at the images I used in the section on justifying the light (page 83). I wrote that scene to take place in a spot where I could justify *red* lighting. The character shown is the most evil one in the film and this scene is his

Required Viewing

Red as a Symbol

Movie to watch: *The Matrix* (1999)
What to keep in mind: In the scene where Neo is being taught how to walk about in the matrix, he is distracted by the woman in the red dress. Here, red symbolizes an allure that could get him in trouble.

most evil moment. I did not want the entire scene to be red, though, just this character.

Some people associate red with love (Valentine's Day decorations, red roses, etc.). Psychological research has even shown that men find women who are wearing red to be more attractive. Sometimes, the two sides of red are combined (see the "required viewing" section above).

Filmmaking is all about small details that add up to one intricate moment.

The beauty and challenge of being an artist is that there are no absolutes. There are *many* ways to use red lighting to enhance the story in your film.

Yellow. In film, yellow is the opposite of red. It is cheery and warm. If you want to give off the feeling of the sun, then yellow is your color.

On pages 88 and 89, take a look at the yellow lighting used in another part of the scene I referenced in our previous discussion of red lighting. In the scene, the character with evil intentions is lit with red. However, the other character is lit with yellow to represent his good intentions. Over the course of the scene, the red light begins to bleed onto him, representing the evil being transferred to him. When the scene ends, he has a slight red outline. This might seem like a small detail, but filmmaking is all about small details that add up to one intricate moment.

Again, this does not mean that using yellow lighting will automatically tell viewers that a character has good intentions. This effect only works in partnership with the scene, the characters, their dialogue—and, here, the contrast between one character being lit red and the other being lit yellow. The light is only the icing on the cake.

Blue. Blue is, quite simply, cold. Lots of scenes with snow, or when you can see the characters' breath, have a subtle blue tint to give the viewer a sense of the cold. Again, the blue tint only works in combination with other "cold" elements—like snow or characters wearing a lot of warm clothing. Also, be careful when selecting this coloration; you would not want to use it for a happy moment in a film.

You won't get blue light just by adding blue gels to your tungsten

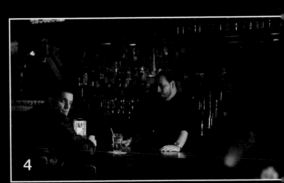

This scene was lit with tungsten light, but I shot it at the daylight white balance setting. Then, I removed some red in postproduction. As a result, my subject is properly balanced for the room, but there is an overall dark, amber feel to the scene.

lights (that just balances them to a neutral daylight coloration). To give a scene a blue tint, you want to control the Kelvin setting on your camera. Based on the light you have, dial in whatever setting you need to give you a blue tint. Alternately, you could add the blue tint in postproduction.

Amber. Warm, amber lighting is usually associated with magic hour or sunset. Sunsets feel great, look great, and are romantic in a very cinematic

fashion. You can make a scene warm with orange gels on the lights, by adjusting the color settings in the camera (boosting the red in the RGB), by lighting something with tungsten and setting the white balance to daylight, or by enhancing the red in postproduction. There are many options. This is my most commonly used color of lighting.

Whenever I shoot a scene that takes place in a bar, I always light it darkly

and often with an amber coloration. In the image sequence on the previous page, you can see how a particular bar scene was lit. I felt the scene had a darker sense overall, but my character was warm and I wanted my audience to perceive him that way. Amber is also the color of some street lights, so it is a simple way to light a street at night time.

Final Thoughts on Lighting

Lighting is an art form that should be taken very seriously. Just throwing up some lights and getting some light in the scene is not enough.

Think of your image like a painting. If I press pause anywhere in your film, I should be able to see the artistry in that frame. Be methodical, experiment, and stay disciplined. Let your scene tell you how to light it. Watch movies and pay attention to the mood of the scene and the type of

Lighting is easily the most challenging part of being a filmmaker . . .

lighting schemes they use. Observe the repetition of certain emotions and how they relate to lighting. Lighting is easily the most challenging, time-consuming part of being a filmmaker, but once you get it right, you are a real filmmaker.

7. Show, Don't Tell

We have been concentrating on the technical side of things for a few chapters, but now it's time to come back to some important theory. Think all the way back to shot sequencing. We know that scenes need to be broken down into different shots. This leaves us with a question: *What do I film to get my story across?*

Whether you are making short films or feature films, time is of the essence; you have very little time to deliver a lot of information. This is why the theory of "show, don't tell" is critical—it's how you deliver information in an effective and efficient way. In filmmaking, we use audio for enhancement, but the visuals tell the story. In fact, you should be able to get an idea about the nature of the story even if you watch it with the volume at zero. We have all heard the phrase "actions speak louder than words," and it's just as true in filmmaking as it is in life. Your viewer will remember and understand everything better through visuals. If you have the opportunity to say something with an image, do it.

We are going make our way slowly through this concept so we have a real understanding of how to do this when all is said and done.

Delivering Information

Get Objective Analysis. The biggest challenge for any filmmaker is removing themselves from their story. Every filmmaker, at one point or another, struggles with this. As the filmmaker, no one knows your story better than *you* do. You'd think that would be a good thing, but sometimes it comes back to bite you. Your complete understanding of the story can make it tricky to decide what information needs to be included so that everyone else can understand the story. If you leave out key pieces of information, your story may not make sense.

Often, for example, you have background information on the story that viewers do not. As a result, you may look at your film and think all makes perfect sense because, in the back of your mind, there are little bits of information you're using to piece the

Even without audio or motion, the pictures communicate what this story (above and facing page) is about.

story together. The viewers, however, are not privy to those bits of information in your head. The best way to combat this is to have other people view your story before releasing it to the public or delivering it to the client. Ask them questions about the story and see if they can answer them. Every story has a list of questions that should be easy to answer after one viewing.

Identify the Defining Actions. The most important thing is the central plot/concept of your film. It is obviously a failure if someone watches your film and says, "So, what was that about?" To keep your message on track, identify the defining actions in your story. Find the one plot point that defines your film and make sure that part of the film is defined purely with the visuals (audio can aid the

process, but it should not be critical to the viewer's understanding).

Let's think, again, about the film *The Matrix*. What is the movie about? It is about the matrix—a "dream" world that exists to keep us blind to the truth of the "real" world. The plot is clearly defined in a scene where Morpheus shows Neo the difference between the worlds. It starts in the matrix, in an all-white room where they are sitting in chairs. Then, the scene shifts to the real world, where Morpheus shows Neo how humans are used for energy. Even if I mute the television during that scene, I can still see the contrast between the real world and the matrix. I can identify the conflict and begin to anticipate the possible resolution. There is no need to hear a thing. Does it help to listen to what they are saying? Sure. Do I get more information from the audio? Yes, indeed. However, I can grasp the overall concept simply by watching the images.

This is the question you need to ask yourself every time: What is my film about? On the facing page and below is a series of screen shots. Even without motion, it is clear what's happening here. A girl is opening a card,

Required Viewing

Show, Don't Tell

Movie to watch: *The Matrix* (1999)
What to keep in mind: Watch the scene where Morpheus demonstrates the matrix/real world to Neo. Even with the sound off, you understand what's going on—and the film's core conflict.

Skip the Conversation

Connecting and developing characters is best done through visuals because the process is quick. Including a shot of two people holding hands with their wedding bands on is much more efficient than including a scene of them washing dishes while discussing their marriage. Characters are easily developed through images, so there is no need to waste time doing it through conversation. Reserve the conversation for getting deeper into the characters' minds—and for things that cannot be established with a simple shot. Save as much time as you can for story development.

reading it, and then opening a gift. We also get to see the man buying the gift and writing the card. We even see a shot of what's written in the letter. And we know what country this story takes place in. We understand the plot.

This is from a wedding film I made years ago. Why are there no shots of the wedding? Well, they are in the actual film—but that is not what *this* story is about; this story is about one moment. Does the audio in the final film make it better? Yes, it does. But we should always be trying to tell the story with just the visuals. Then, the film becomes even more powerful when we add audio to the equation.

Developing Characters

It does not matter what film you are making—a wedding film, a business film, or a feature film—the one thing all filmmakers have in common is that they are dealing with characters who drive the story. A huge element of the "show don't tell" approach is developing characters. This is best done through visuals.

In many cases, what helps the viewer identify with a character is not what they are saying but what they are feeling. This means that facial expressions are your best storytelling tool when it comes to character development.

In staged filmmaking, you have complete control of what the characters are doing and it is important to know what facial expressions are necessary to make your point. You also need to ensure you demonstrate the connections between characters that are required in order to develop relationships. There are many ways to establish relationships and feelings without saying a single word.

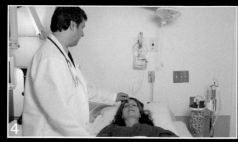

You can demonstrate relationships and feelings without a single word.

Above is a series of images from my last film. Looking at this scene, what do we know? A husband, who happens to be a doctor, is sitting in a hospital room with his sick wife—and he cares deeply for her. How do we know this? Well, she is obviously in a hospital bed, and he is obviously dressed like a doctor. Beyond that, we see his facial expressions and the way he touches her, all of which reveal his love for her. We also know they are husband and wife based on the close-up of the wedding ring. All the information is there. Do we know what ails her? Nope. Does it matter? Not entirely. The purpose here is to communicate the general facts with imagery alone. The other details may either be established by another part of the story or through the audio.

But what if you are a live-event filmmaker and not in control of your scene? The opportunities to show emotions and relationships are all over the place. It is your job as a filmmaker

Required Viewing

Easter Eggs

Movie to watch: *Fight Club* (1999)

What to keep in mind: Many, many viewings will be required to find all the Easter eggs in this film—but every time you find one, your experience of the film becomes richer.

to find them and piece them together while they are happening. Admittedly, this is no easy task and the opportunities within a job may vary. At a live event there is no yelling "Cut!" and there are no do-overs. You will need to get it right when it happens.

In my opinion, the better you are at staging emotions, the better you will be at recognizing them at live events. If you have never made a staged film in your life, I would suggest doing a few commercials or a short film or two. This will give you a good advantage when you are trying to capture these emotions and interactions during live-event filming.

Easter Eggs

One of your jobs as a filmmaker is to enthrall the audience to the point they are actively participating in the story. If it is a mystery, they should be trying to solve it. If it is a love story, they should be in love with one of the characters. If it is an adventure story, they should feel like they are on the journey.

A great way to get people involved in the process is by including some more obscure elements. These are things that might go unnoticed—but, once seen, serve to enhance the viewer's understanding of the story. We call these hidden gems "Easter eggs." They are so prevalent in cinema that I'd be hard-pressed to think of a movie that is missing them (although some films have many more than others). Easter eggs are one of those things that most viewers never notice—but for the people that do, it is extremely rewarding. If a viewer notices an Easter egg, it makes them feel smarter and they automatically become more engaged in the film. Easter eggs make your film worth a second or even third viewing.

One of your jobs as a filmmaker is to enthrall the audience . . .

I want to use the film *Fight Club* as an example. To me, it's the greatest movie ever made—and I believe this is largely based on how many Easter eggs are scattered throughout the film. It took me hundreds of viewings to catch them all—and I'm still not sure I've seen *every* Easter egg buried in the film.

In the film, the main character played by Brad Pitt) is not introduced for about 20 minutes, but he is flashed in single frames on the screen over a dozen times. This is a fascinating Easter egg because it connects that character to his night job as a projectionist—one with a penchant for splicing single frames of other films into the movie he's showing. When he speaks about this practice, he says, "Nobody knows that they saw it, but they did." The irony, of course, is that the same thing has been happening to *you*.

In the establishing shot of the main character's apartment building, the sign reads: "Pearson Towers: A Place to Be Somebody." There is a back story on this Easter egg. This film was written to be shot in the state of Delaware. Because he was not ultimately allowed to shoot there (the state objected to the plot), director David Fincher littered the film with many hints referring to Delaware. In this case, the tower sign mimics the slogan of Wilmington, Delaware ("a place to be somebody"). The name "Pearson" comes from Pearson Elsmere, the founder of Elsmere, Delaware (a town adjacent to Wilmington).

David Fincher littered the film with many hints referring to Delaware.

The list goes on and on—I could write an entire book on this movie alone. The point, however, is that those Easter eggs make your film more valuable. Call them gifts that keep on giving—and reward repeat viewers of your film.

8. Types of Stories

There are countless ways to tell a story. It is one of those things that can never be absolutely right or wrong—just better or worse. To get started, though, you need to understand the different types of stories. I will start by pointing out the difference between linear and non-linear stories, then break down the types of narratives you can tell.

The type of story you have set out to tell and the point of view from which it is being told are decisions that will affect your shot selection and camera angles, so you and your crew need to be on the same page. Understanding these approaches will help you avoid making poor (or confusing) choices.

Linear *vs.* Non-Linear

When you are telling your story, there are two directions you could go: linear or non-linear. Although it is extremely beneficial to know ahead of time, this is not a decision that *must* be made before you shoot. During the editing process, you could decide that the lin-ear story is not working and go with a non-linear approach.

In a linear story, the events are presented in chronological order, from start to finish. Sometimes, the story, from beginning to end, is just that good. More often, the story needs a little help, which we can provide by moving to a non-linear presentation.

Presenting things out of order very often makes the story more intriguing.

It sounds crazy, but presenting things out of order very often makes the story more intriguing. For example, can you imagine watching *Pulp Fiction* if all the stories were told in order? The non-linear story keeps the viewer on their toes, always trying to work out the "big picture" in their heads.

There are countless ways to tell a story out of order in order to strengthen the plot, but I will share a few methods (along with my made-up

names for them) that I lean on when I think about non-linear stories.

Innercutting. In this approach, two scenes are combined into one fluid scene, cutting back and forth as you lead the viewer toward one final climax. If you have two mediocre moments that share the same purpose (they naturally connect), they might form a more intriguing scene together. Try to have them lead into one another. For example, if the first scene has a character asking a question to another character, and the second scene contains the answer, use the first scene to set up the question and innercut the other scene to reveal the answer. There is no limit to the number of scenes you can innercut. However, the more scenes you use, the more complex the story becomes. To pull this off, you need to be very good at dishing out information by showing and not telling.

The Teaser. The teaser is easy and very common. Creating a teaser involves taking a scene from the middle of your story (usually something close to the beginning of your climax) and dropping it right at the beginning of the film. This has a great effect. As your film starts, the viewer has no clue what is going on. Then, the teaser scene ends and the real film starts. You now have the viewer participating in the process as they try to determine how the film is going to build to that moment. When you finally get

back to that teaser scene, it acts like a double climax; the climax of the story is happening, but there is a secondary climax happening in the viewer's mind. Since they have seen the scene already, they are now rewarded with an understanding of how it ties into the story. This dresses up your climax to make it feel even more exciting. If your climax is good, you can really smack your viewer over the head with this one—but even if your climax is a little weak, this approach can help save it.

> This dresses up your climax to make it feel even more exciting.

The Vehicle. For this aptly named approach, you use a main feature of your story (maybe a speech or a conversation) to navigate through the story. This is commonly used in

The Vehicle

Movie to watch: *Forrest Gump* (1994)

What to keep in mind: Forrest, talking about his life as he sits on a park bench, is the vehicle for this story. The vehicle sets up the cut-away to each of the scenes.

documentaries, where interviews often become the vehicles. Think about the movie *Forrest Gump*, which is basically about a guy on a bench telling a story to anyone who will sit there and listen. Forrest, on the bench, is the vehicle—and they use him to maneuver throughout the story. The individual incidents do not have to be shown in chronological order because the vehicle correctly sets up each cut-away. This is a technique that live-event filmmakers should be drawn to. Wedding vows and speeches by CEOs at corporate events make for good vehicles. They provide a framework that takes the guesswork out of assembling the story; the vehicle will tell you what comes next. The vehicle determines the narrative.

Narrative Point of View

When you attack a story, you need to know from whose point of view it is being told. This directly affects the way you shoot—from your camera angles to your camera movement.

First-Person Narratives. In a first-person narrative, the story is told from the point of view of the main character. (It can be more than one character if your story is structured correctly, but it is usually one person.) This is my favorite point of view, and it's the most common way to tell a story.

When you tell the story from the first-person point of view, your audience "becomes" that character. This is the secret to capturing viewers. If you have a character you think a mass audience is going to relate to, then a first-person narrative is usually the best way to go.

> This is a technique that live-event filmmakers should be drawn to.

In first-person narratives, the key is to put the audience in the same position as the character. This means everything that happens to this character also happens to the audience. The audience becomes aware of information exactly when the character does. They also see things for the first time along with the character. For example, if you were telling a wedding story from the point of view of the groom, you would not want to show the bride in her wedding dress until the groom sees her. The suspense lies in *the viewer* not seeing her until

the groom sees her. Conversely, if the story were told from the point of view of the bride, the moment would be about the groom's *reaction* to seeing the bride in her gown.

In a first-person narrative, the viewer and your main character take the journey together. This also means the viewer should know what the main character is thinking most of the time. In many movies told in first person, the main character actually narrates the story. The television show *Dexter*, for example, would not be great without Dexter's narration. It's through this narration that we know what he is thinking while the rest of the characters do not. Because of this, we identify with him—and we are, essentially, keeping his secrets.

The viewer and your main character take the journey together.

Shooting a first-person narrative does affect the camera angles and movements. You will see more point-of-view camera angles in your film because you'll want to show exactly what your main character is seeing in many of the scenes. The camera movement will also change because you will want the hand-held, fly-on-the-wall look more often. This is why it is so important to know what type of nar-

rative you are making; it tells you how to shoot it.

Second-Person Narratives. Second-person narratives are told from the point of view of characters referring to the main character. This is an uncommon (and complicated) narrative style that does not translate very well to film. However, it can be effective to select moments in your film and shoot them as if they are being told in the second person. A good example would be an intervention scene. You have been telling the entire story in first person, then a scene happens that is an intervention.

Required Viewing

Omniscient Narrator

Movie to watch: *The Hitchhikers Guide to the Galaxy* (2005)

What to keep in mind: The narrator is all-knowing—and, when you hear him, it is unmistakable why this is called "omniscient third-person." (It also happens to be my favorite movie.)

Suddenly, for just that specific scene, the audience takes on the perspective of the entire group against the main character. They will often refer to the character as "you." It would be rare to run into this at a live event, such as a wedding—but if you were at a Jewish wedding and there was a document signing, that situation could be told in second person.

Third-Person Narrative. The third-person narrative is another very common approach. This is when the audience does not ride along with any character but acts as a bystander to the whole story, viewing it from the outside. When in doubt, this is the easiest to pull off and allows for the most flexibility.

There is also something called an "omniscient third-person narrative." This requires an actual narrator who knows what every character is thinking and feeling—a narrator who knows *everything* about what is happening. This approach is often used in documentaries, where a narrator is needed to tie together all the footage and stories.

9. Audio

Think that mastering the image-creation process is enough to rattle your brain for two lifetimes? Well, welcome to what some filmmakers actually believe to be the most difficult part of filmmaking: audio. Happily, this doesn't have as much to do with actual difficulty as with the discipline required to get good results.

Before we get into anything having to do with audio theory, let me just say that I am not an audio engineer—nor is any filmmaker, for that matter. In the movies, they actually employ an engineer to get perfect sound. If you have the budget for an audio engineer to mix the sound for you, I recommend making that investment. Even without an engineer's assistance, however, you should still be fine (unless you are making a movie for theatrical release). Just remember to keep your goals in mind and treat the audio as if it were as important as the visual. As many studies have shown, audiences will forgive bad visuals, but not bad audio.

Recording a Clean Signal

If you are like the rest of us, you're doing it yourself. In that case, here's the main goal: RECORD A CLEAN SIGNAL. That's it. If you record a clean signal, you can do anything you need to the audio files and achieve the sound you want for your film. You may be able to fix a poorly exposed image with some color correction, but if you record a damaged audio signal—it's game over.

Studies have shown audiences will forgive bad visuals but not bad audio.

There really is not a lot to this beyond making sure the levels are correct. The prime recording levels are around –6dB (decibels). If you are recording voices, you should not have anything else (music, sound effects, etc.) in the recording. Everything in audio, just like video, is recorded in pieces and put together in the edit-

ing room. For example, if you want to have a phone ringing in the background while someone is talking, record the voice and the phone ringing separately.

Someone should always be listening to the recording through headphones. Use a good pair of noise-canceling headphones so you are not confused by background noise. Even if you are a one-man band, I would recommend hiring an assistant to monitor the audio if you will be recording externally. If you record everything in the camera, leave the gain on auto.

Ambient Audio

The notion that we need to record voices cleanly to include them in our film is obvious—but what about everything else? Ambient audio is the lifeblood of your film, but probably the most underrated element.

> Pick a movie, any movie, and watch it just to observe the ambient audio.

What is ambient audio? It is the sound of everything you see. If you see a city, you hear it. If someone opens an envelope, you hear the paper crackle. If someone is tying their shoes, listen closely to the laces rubbing together. It is anything and everything you think doesn't matter.

Ambient audio is one of the biggest tricks in the bag when it comes to making viewers feel like they are in the room, so it is important to have as many of these sounds as possible. Pick a movie, any movie, and watch it just to observe the ambient audio. If you are watching a good movie, anything you see that can make a noise will most likely be heard in some capacity.

If you have the time to record these sounds separately and correctly, take the time to do so. If, on the other hand, you are flying by the seat of your pants at a live event, then adopt my policy: no audio left behind! If you are caught with no onboard mic (using only the camera's built-in mic), the voices will sound terrible. You cannot record the main audio track like this.

However, this mic does a pretty good job of picking up every little sound in the world. (Which is precisely the reason you cannot record voices with it.) The ambient sound it picks up can be lowered significantly in the background on the editing board, hiding the fact that the quality is awful. That audio is still doing you some good in the background, though. There is no such thing as too much ambient sound.

When Silence Is Golden

If your audio is well-executed, there will be a noticeable change when you eliminate the sound. This can be done

o completely remove the viewer from the story for a moment. For example, let's say you're telling a first-person narrative—but then an extreme event happens and you want to switch to the third-person, so the viewer can see the story from the outside, looking in. This is a good time to fade out all of the audio for a few seconds. Let the film be silent. Remember, ambient audio gives your film life. By removing it, you can take the life away. This is something that does not happen often, but if you run into the opportunity and miss it, that would be a shame. These silent moments are some of the most powerful in film and are often complemented by a slow-motion image. (I would do this only once during a film, and I would wait for an intense moment near—preferably after—the climax.)

Sound Relative to Distance

According to the "record a clean signal" theory, you should record (at the proper level) every sound you want to include in your film and then mix them later to make everything sound full and clean. Another approach is to acknowledge that sound is relative to distance. This coordinates well with the idea that the camera is your viewer. If this is the case, the volume of any ambient sound (not the main dialogue; that must be recorded cleanly) should be based on how close or far it is from the camera.

Required Viewing

Sound and Distance

Movie to watch: *The Social Network* (2010)

What to keep in mind: Near the beginning of the film, the main character runs from a bar to his dorm. Notice how the sound of his footsteps changes with his distance from the camera.

Watch the opening scene of *The Social Network*. After the initial conversation we discussed in chapter 4, there's a credit sequence with the main character running from the bar to his dorm. The shots are held on screen for quite a long time, during which you hear some ambient noise but mainly the character running. You hear his footsteps loud and clear. As he gets closer to the camera, the footsteps get louder; as he runs away, they fade into the distance. I cannot

As he gets closer to the camera, the footsteps get louder . . .

say for sure if the mic was on-camera picking up the true distance of the footsteps or if they made it sound like this in postproduction—but it is a *very* realistic representation of the sound.

This is just another way to make a film feel real. If the footsteps had remained loud and clear when the subject was 100 yards away, we'd likely perceive it as synthetic.

You can never go wrong with recording everything clean and changing it later.

That said, you can never go wrong with recording everything clean and changing it later. In fact, recording the true distance of something is risky because you are essentially locked into the volume of that audio sample. If you later decide that you want to increase the volume of something that was recorded far from the microphone, you will have a lot of problems doing so. So, recording true sound is risky—but if you can pull it off, it is more rewarding and real. (And anything worthwhile comes with risk, right?)

Foley Artistry

So what happens if you don't capture those ambient sounds? It does happen. Sometimes, it's just by accident. Sometimes, your signal may not be strong or clean enough. This does not mean you have to accept defeat and settle for not having a full audio mix, though. If you do not have the sound effects you need, make them.

Every movie you see in the theaters has someone working on the film known as a foley artist. At the highest level of film production, the foley artist goes into their studio and records all the needed sound effects after the film is shot. They look at the man walking on the screen and then create footsteps that sound as real as what you would hear if you were standing right there. As they record it, they sync the sound to his steps and add the natural fade as if they were really walking away from the camera.

This goes for anything and everything that you would need sound for. In fact, most movies have some element of foley in every scene. Sometimes foley sounds even better than the real thing. We have all seen a good old-fashioned fight scene—but do you really think it sounds that loud and clear when people punch each other? Nope. If you listen hard enough, it sounds borderline fake. However, we know the viewer is not listening that hard, so the overexaggerated punch sounds help the fight feel more real. (Watch any of the *Bourne* films to witness this.)

Foley artists get very creative when it comes to making sound effects—and you can, too. Sitting at your computer with your mini-recorder, you can record many sound effects that would be very useful to you in your film. If you find yourself in a situation where you are saying, "I wish I had

ecorded that sound," just re-create nd record it after the fact.

ustify the Sound

There is a fine line between sound effects that are enhancing and ones that are distracting. I am always on the side of using sound effects to our advantage, but that means justifying their existence. Just as when you light something and the light has to represent something that looks real, any sound you add must sound real. If there is a questionable sound effect in the background, you would want to show the source of that sound.

What do I mean by "questionable?" For example, say you are shooting a scene in an office building. You establish the outside of the building, demonstrating that it is obviously an office. Then you show a nice, smooth dolly shot down a row of cubicles filled with employees on their phones. Finally, you Steadicam past the community kitchen and into the supervisor's office, where a conversation is taking place. During this conversation an obvious sound effect would be having phones ring in the background. Do you have to *show* a phone ringing? No, because the office setting has already been established. Your audience will make sense of this sound.

Instead of a phone ringing, what would happen if the audience heard the sound of peppers frying? When you think of an office building, the

sound of peppers frying does not come to mind—so this is when you must justify the sound. If you don't, the audience might think the sound is a mistake. The easy solution is to add an establishing shot. Let's backtrack to that Steadicam shot, going past the kitchen again. This time, we pass Joe in the kitchen—and cut to a shot of him tossing those peppers into the pan, revealing that he's decided to fry up some lunch. Now the audience knows where the frying sound is coming from when they hear it in the background of the conversation in the supervisor's office. If the kitchen will never be in your scene, then there is no need to show or hear anything from the kitchen—but if it will be part of the scene, you need to justify all the sounds before or during the shot.

You can use the sound it makes to build anticipation . . .

You can also take the opposite approach. If whatever is making your questionable sound is a huge element of your scene, you can use the sound it makes to build anticipation. You can fade in the sound but not show the source for a short amount of time. When you finally reveal what's making the sound, the audience will feel a subconscious sense of relief.

Music

Selecting music is one of the most challenging parts of filmmaking. It becomes difficult to step away from what you love and strictly do what is best for the scene. I cannot tell you how to pick the best music for your film; it is a skill that comes with practice.

What I *can* tell you is not to let the music control you. They call it a score for a reason—it happens *after* the film is edited. A lot of novice editors pick their music and cut the film to it. You should absolutely take the beat of the music into account when editing, but you should not let it control you. I always edit my scene, then pick music, then go back and tweak the cuts to match up better with the music.

Another thing to keep in mind is length. Just because a song is 4 minutes and 30 seconds long does not mean the scene you use it in should be that long. You should always cut/extend the music rather than changing the length of your scene.

The best advice I can give is to let the scene talk to you. Think about what emotions you are trying to convey. Music is integral to the emotional undertone of a film. When I saw the first cut of my first feature film, it had no music. When it was over, I literally got sick. I bemoaned, "We just spent all this money and time making a movie that has no emotion at all!" My music supervisor looked at me and said, "Don't worry, it just needs a little music." He was right. Once the film was scored, every scene felt different. It was amazing to see the power of music and what it can do for the emotion of your film.

This does not mean every scene needs music, but selecting the right music when you *do* need it is very important.

Ambient Music

Another way you can justify sound is to build music into your scene. The vast majority of films have music added to them during the editing process. However, you have also seen examples of a musical performance going on during the scene, and that ambient music serving as the background sound for the scene. This is very risky because you cannot change your mind after the fact. If you can do it well, you are playing at the highest level.

10. Editing

Congratulations on making it to the final chapter! Finally, it's time to take all of these elements and put them together into one seamless, breathtaking film.

You can't master editing through words and pictures (you need to work with the software and some actual footage)—however, I can teach you some important points about the theory of editing. As you sit behind an editing board, these are things you want to have in mind. (Or if you are hiring someone to be your editor, you'll know what to look for.)

Know Your Idea

If you have the finished film in your mind (or on a storyboard) before you sit down, editing is no different than assembling a puzzle. No one in their right mind would try to put together a puzzle without looking at the outside of the box, right? You should practice the same concept when it comes to filmmaking. Know your idea *before* you edit.

Organize

When it comes to organization, pretend that you will wake up every morning with amnesia. This ensures you will always understand where everything is (or if someone else takes on the project, they will understand). Logging footage is the first thing to do. For this, I use a program called Adobe Bridge, which lets you browse full-screen previews, scrub through footage quickly, and create new folders—all with very little processing power. I watch every clip before I edit. I organize the clips into categories and take notes on each one.

Pretend that you will wake up every morning with amnesia.

Logging footage is a discipline, but it's important to know exactly what you have and where it is. Editing is a flow that involves long sessions. In

my world, editing sessions run 4 to 10 hours—and during that time, I want to be creating. I do not want to stop and embark on a 30 minute detour every time I need a particular clip. This is why everything is carefully logged. When I need to find a clip, I open up my trusty note pad and see what my notes say. The whole purpose of organizing is to save you time on the back end.

Avoid OCD Editing (At First)

The biggest mistake new editors make is they want to make everything perfect as they go. This is one way to do it—but it's the long way. If I am making a 7-minute short film and I spend 4 hours making the first 18 seconds perfect, I'm in trouble.

As you go through the editing process, you will find that things change.

As you go through the editing process, you will find that things change. Your ideas will evolve. By the time you get to minute 2, that first 18 seconds of footage may have changed five or six times. Therefore, spending a few hours on the beginning early in the editing process is simply counterproductive. A better method is to go through the whole project over and over again.

Try laying down a complete cut of your film/scene as quickly as you can. This does not mean make it awful, just lay it down *quickly*. When editing, you want to work from a bird's-eye view for the most part—you need to think about the big picture. How is what I do in the first 20 seconds going to affect the last 20 seconds? By laying down a track quickly, you give yourself the ability to analyze the *whole* film and not just a few seconds at a time.

From there, keep going through the whole thing over and over until you get to a point where the central structure is there and you can start to focus on the fine details. This is when you become anal about every little cut. And when I say "anal," I'm not just talking about critically observing every second, I mean editing every *frame*. There are 24 frames in every second, so a second becomes an eternity in a film.

In the beginning of the editing process, think about the big picture. When you get to the end, however, it's time to start focusing on the smallest of details.

Cutting

When it comes to cutting, there are (again) a lot of intangibles. However, there are some skills I can explain that are extremely important to the editing process. There are two cuts we will focus on: the L cut and cutting on the action.

The L Cut. An L cut means bringing the audio in before we see the video. You have seen it countless times in television and movies. An L cut's finest moment happens during a conversation. Sarah is talking to Charlie, but the camera is looking at Charlie's reaction. We see Charlie's face, but we hear Sarah. During the middle of a line it cuts to Sarah. That is an L cut. This happens over and over again through the conversation. Another popular use for it is when you hear the audio from the next scene at the end of the previous scene—and then the visuals eventually cut to the scene from which the audio originates. This is a very common scene-to-scene transition.

Cutting on the Action. This technique is usually reserved for when you have two camera angles—or if you shoot the same scene with multiple takes. If you are a live-event or documentary filmmaker, this will work for you, as well. Cutting on the action means cutting from one shot to the other during the middle of the movement. If I filmed a baseball game with two cameras on the pitcher, I would cut from camera one to camera two in the middle of his windup. In film, your eye follows movement, so if you cut in the middle of the movement, the cut is hidden by the continuity. If you have multiple cameras on a single movement, cutting on the action is easy. If you are doing this live, then you need to find shots that match each other. You want to do a little editing in your mind and find ways to capture clips that you can put next to each other and make them feel like one moment. It will happen less often in a live event, but it is absolutely something to look for.

Pacing

Pacing is the heartbeat of an edit, and it's something you'll learn through practice and study. It's important to remember, however, that "pace" and "time" are not the same thing. The pace of a film/scene has nothing to do with how long it is. In many cases, cutting down a film's length improves its pacing.

Find ways to capture clips that you can put next to each other . . .

The first and most important thing you need to understand about pace is purpose. Every clip should have a purpose. Do not throw in clips because you are trying to fill up time. That is a sure way to make your film drag.

Keep an objective outlook and ask yourself, "Does this clip move the story forward? If I remove this clip, does the story still make sense and feel fluid?" If you have that attitude when making the final edits to your scene,

your films will often have the proper pace.

Time often gets in the way of having a well-paced film. You should never have a desired duration in mind before you edit. If you are set on making this scene 4 minutes long, then you will. In a lot of cases, that same scene could have been delivered in 2 minutes. (And that extra 2 minutes? That's time you've given your audience to check out of your film.)

Pace is something that needs to be practiced and studied. I suggest finding some footage you have already edited, then re-cutting it to see if you can shorten it and retain the same message. See how short you can make it. This does not mean you have to make things as short as possible, but you do want to get in the habit of being stingy with your clips.

Pace is something that needs to be practiced and studied.

If you want to learn editing hands-on, go to www.outoforder.com and see all the editing information I can offer you there.

Conclusion

My final thought on storytelling through film is upbeat. Get out there and do it! Do not wait for the perfect situation—just start making films, even if they start out bad. The experience of having an idea in your mind and then taking all these steps to create a final product is the most rewarding feeling I can think of.

The best way to become a good filmmaker is practice. I did not go to film school. One day, I woke up and said, "I'm making movies." Here I am today. My first film was bad—*really* bad. Then I studied other films. I made a second film. I kept creating and creating until one day it all just clicked. Sometimes you focus on one aspect and forget another. Then you overcompensate for what you forgot last time and forget something else instead. Eventually, though, there will come a time when these theories just become part of you. You never have to think about them.

At that point, you are just focused on stories. People ask me how I come up with my actual concepts for films. I usually respond with, "It's easy when it's the only thing you're thinking about." I do not think about justifying light or sound; I just do it. The more you practice, the closer you will be to having these things come as second nature.

Always chase perfection, and always know you will never get there. Perfection is a direction, not a destination—and filmmaking requires a lifetime of learning.

Glossary

Acts. A way of explaining the structure of a story. Act 1 is the exposition, act 2 is the climax, and act 3 is the resolution.

Ambient Audio. The sounds created by everything in the scene. Including this is a key factor in making settings feel real.

Antagonist. The character (villain) who acts in opposition to the protagonist (hero).

Anticipation. Building a sense of suspense within a shot sequence and/or within the film as a whole. The building of suspense concludes with a moment of revelation.

Aperture. The size of the lens opening through which light enters the camera. This can be adjusted to control the depth of field and exposure. Noted as f-stops.

Aristotle's Unified Plot. A linear concept dividing the narrative into three sections: a beginning, a middle (the climax), and an end.

Bird's-Eye Angle. Shooting from a high camera position to provide an overhead view of a scene. This is often used in establishing shots.

B-Roll Shots. Secondary footage that does not advance the story but helps enrich it. In live-event filmmaking, B-roll footage is critical for maintaining a seamless look when rearranging shots.

Camera Angle. The position of the camera relative to the subject or scene, particularly in relation to height. *See also* High-Angle Shot, Low-Angle Shot, Eye-Level Shot, Point-of-View Shot, Bird's-Eye Angle, *and* Worm's-Eye Angle.

Camera Movement. Changing camera position during a shot. This helps simulate the dimensional character of the real world by depicting foreground and background objects crossing each other in the camera's field of view.

Car Mount. A support used to affix a camera to a car.

Cat in the Window Shot. A transitional shot added to allow for a change of perspective that would violate the 180 degree rule.

Character. The personalities through which viewers transcend themselves into the story. *See also*

Antagonist, Protagonist, *and* Secondary Character.

Cheating. Adjusting the light or sound as needed to achieve your desired results without violating the viewer's sense of the reality of the scene/setting.

Chronological Order. Presenting the events of a story in the temporal order in which they occur.

Climax. The turning point of the story, normally when the character overcomes the central conflict.

Close-Ups. A tight view of the subject's face or some important aspect of the environment.

Composition. The arrangement of subjects and scene elements within the frame. *See also* Rule of Thirds.

Concept Films. Films with stories that center on a theme rather than a plot.

Conflict. The dramatic struggle between two opposing forces in the story. *See also* Relational Conflict, Situational Conflict, Inner Conflict, Paranormal Conflict, Cosmic Conflict, *and* Social Conflict.

Cosmic Conflict. A human *vs.* destiny/fate conflict, usually between the protagonist and a supernatural force (such as God).

Crane. A camera support used for shots (often with movement) from high angles.

Crop Factor. A reduction in the angle of view resulting from using a camera with a cropped (less than full-frame) sensor.

Curved Dolly Shot. Moving the camera along the arc of a dolly track (or simulating the look by rotating the camera while moving it along a straight dolly track).

Cutting on the Action. In editing, jumping from one shot to another in the middle of movement. This is generally reserved for circumstances where you have film of the same scene from two camera angles or multiple takes.

Distortion. An inaccurate rendering of shapes and sizes due to camera position or inherent lens effects.

Dolly. A straight or curved track fitted with a rolling mount used to move a camera along a smooth course. Also called a slider. *See also* Curved Dolly Shot, Dolly In, Dolly Out, *and* Push/Pull Effect.

Dolly In. Moving the camera toward your subject while simultaneously pulling focus.

Dolly Out. Moving the camera away from your subject, often at the end of a scene.

Dutch Angle. Tilting the camera to one side or the other, producing a feeling of disorientation.

Easter Eggs. Obscure elements added to a film that, when detected, help engage viewers with the film (and reward repeat viewers).

Establishing Shot. A shot that reveals the setting for the action. This could be a wide shot (to show the whole scene) and/or close-up shots to reveal important details of the setting. Sometimes called a scene-setter.

Exposition. The part of a story that sets the scene for the viewer,

revealing the location, the characters, the basic conflict, and other important details.

Eye-Level Shot. Shooting from a camera height that roughly bisects the area of the subject shown. This prevents distortion and maintains an emotionally neutral point of view.

Falling Action. The post-climax part of the narrative when the story heads toward the resolution.

First-Person Narrative. A story told from the point of view of the main character.

Flashbacks. Moments within a linear story where information from past events is presented.

Fluid Head. A device used to connect a camera to a tripod. Unlike other tripod heads, this device is designed to provide smooth pan and tilt movements.

Fly-on-the-Wall Shots. Shots that simulate a first-person perspective and angle of view.

Foley Artistry. Studio recordings designed to re-create ambient audio as an enhancement to the scene.

Frame Rate. The number of frames that will be recorded in a second. Expressed as frames per second (fps).

Freytag's Plot Structure. Described by playwright Gustav Freytag, a linear plot concept dividing the narrative into five sections: a beginning, rising action, a middle (climax), falling action, and an end. Also referred to as Freytag's Pyramid.

Freytag's Plot Structure (Extended). An alternate version in which Freytag's plot structure is extended to include exposition and resolution.

F-Stop. *See* Aperture.

Gels. Translucent materials used to adjust the color output of a light source.

High-Angle Shot. Shooting down on a subject to make them look smaller or more vulnerable.

Hook. An initial conflict or exciting force that leads into the rising action of the story.

Hyperfocal Distance. The distance between a camera lens and the closest in-focus subject when the lens is focused at infinity.

Inner Conflict. A human *vs.* self conflict where the character struggles with his or her own confidence, ethics, guilt, inabilities, etc.

Innercutting. Combining two related scenes, cutting back and forth to lead the viewer toward one final climax.

ISO Setting. A camera setting that determines the sensor's level of sensitivity to light.

Jib. *See* Crane.

Justifying the Light/Sound. Ensuring that the light or sound used in a scene seems realistic for the setting/context.

L-Cut. In editing, bringing in the audio for a scene before showing the video.

Light Meter. A device used to ensure consistent, accurate exposure levels from scene to scene.

Linear Stories. Narratives in which the story elements are presented in chronological order.

Live-Event Filmmaking. The process of collecting footage as real events unfold. This is later edited into a film that captures the characters and events.

Low-Angle Shot. Shooting up at a subject to make them look larger or more powerful.

Macro Lens. A lens that allows you to fill the entire frame with a small object.

Medium Shots. A shot that focuses on the subject but maintains a view of some of the activity or environment around them. This is the most commonly used shot in filmmaking.

Monopod. A camera support with one leg. Monopods are highly mobile, making them good for live-event filmmaking.

Negative Space. Areas of the frame not occupied by the subject of the shot.

Neutral Density Filters. Fitted over the camera lens, these filters reduce the total amount of light entering the camera.

Non-Linear Stories. Narratives in which the story elements are presented in non-chronological order.

Omniscient Third-Person Narrative. A narrative featuring a narrator who knows what every character is thinking and feeling.

180 Degree Rule. Positioning the camera along an arc relative to the subjects' positions in order to maintain a consistent visual relationship between the characters or to show directional movement in a logical manner.

Pacing. The rate at which the narrative develops. In many cases, reducing the length of a film improves the pacing.

Pan. Pivoting a camera horizontally to track subject movement, add movement, introduce a subject, or create other effects.

Paranormal Conflict. A conflict where the human must push the limits of what he believes is possible (such as when confronting advanced technology or paranormal forces).

Perception of Conflict. The protagonist's outlook on the situation at hand.

Point of View. The camera's perspective on the setting, subject, or interaction. This is the perspective from which viewers will engage with the narrative.

Point-of-View Shot. A shot that puts the viewer in the shoes of one character.

Protagonist. The character (hero) who acts in opposition to the antagonist (villain).

Pull-Focus Technique. *See* Rack Focus Technique.

Push/Pull Effect. Dollying away from your subject while zooming in. Also called the vertigo effect (for its use in the Alfred Hitchcock film of the same name).

Raccoon Eyes. Dark, obscuring shadows on a subject's eyes created by an overhead light source.

Rack-Focus Technique. Changing your focus point from one subject to another in a single shot. Also called the pull-focus technique.

Reaction Shot. A shot that reveals the impact of an event/statement on the character.

Reflector. A device used to bounce light into shadow areas for contrast control.

Relational Conflict. A human *vs.* human conflict where two characters have opposing goals.

Relationships. The connections of the characters relative to each other. These need to be established early in the exposition.

Resolution. The conclusion of the narrative, during which the loose ends are wrapped up.

Revelation. The divulgence that concludes an anticipatory sequence and makes sense of the suspenseful elements presented.

Rising Action. The series of events that lead to the climax. This could be a secondary conflict or a series of anticipatory events.

Rule of Thirds. A compositional strategy dividing the frame with two vertical and two horizontal lines (equally spaced). Placing the primary subject along one of these lines, or at an intersection of two lines, generally results in an effective composition. *See also* Composition.

Scene-Setting. *See* Establishing Shot.

Scrim. A mesh device used to reduce the amount of light reaching an area of the scene or subject.

Secondary Character(s). Characters that share the objective of the main character. If these are of a different age, gender, class, etc., it will broaden the emotional outreach of the story.

Second-Person Narrative. A story told from the point of view of the characters referring to the main character.

Setting. The surroundings in which the story occurs. The setting can help the viewer understand the characters and may also be integral to the conflict in the plot.

Shot Order. The particular arrangement of wide, medium, and close-up shots used in a shot sequence.

Shot Sequence. A series of shots that, when assembled, reveal an individual moment within the larger narrative.

Shoulder Mount. A camera support used to create the look of a controlled, hand-held shot.

Shutter Speed. An exposure control used in partnership with aperture and ISO. The traditional rule of thumb is to set it at twice the frame rate. *See* Frame Rate.

Simultaneous Conflicts. The use of multiple conflicts within a single story.

Situational Conflict. A human *vs.* environment conflict where the characters disagree on how to handle the challenge the environment has presented.

Slider. *See* Dolly.

Social Conflict. A human *vs.* group conflict where the protagonist

faces off against a group of people who collectively function as the antagonist.

Steadicam. A camera-support rig designed to isolate the camera from the cameraman's body, allowing for completely fluid camera movements.

Teaser. A scene from later in the story (usually near the beginning of the climax) that is placed at the beginning of the film to build suspense.

Third-Person Narrative. A narrative in which the audience acts as bystanders to the events (rather than "riding along" with the main character).

Tilt. Rotating a camera vertically, often as a transitional movement into or out of a scene.

Tracking. Moving the camera in a smooth line along a straight or curved dolly track.

Tripod. A camera stand with three legs. Provides good stability but is less mobile than a monopod for live event filmmaking.

Two-Shot. A medium shot showing two characters.

Vehicle. One element of the story (a speech, a conversation, etc.) is used as a framework for the rest of the narrative.

Vertigo Effect. *See* Push/Pull Effect.

Viewfinder. The device through which we evaluate the appearance of the scene as it will be recorded through the lens. (Do not trust your eyes alone to do this.)

Wide Shots. A broad view of a scene commonly used to establish the setting of the scene.

Work-In/Work-Out. A sequence of shots mimicking the way humans experience new environments—beginning with a wide view, then working toward progressively narrower views as we key into important elements. When exiting the scene, this sequence is reversed.

Worm's-Eye Angle. Shooting from a very low camera position, often to show the way children or animals see the world.

Index

Direction & Quality of Light

Neil van Niekerk shows you how consciously controlling the direction and quality of light in your portraits can take your work to a whole new level. *$29.95 list, 7.5x10, 160p, 195 color images, order no. 1982.*

DON GIANNATTI'S

Guide to Professional Photography

Perfect your portfolio and get work in the fashion, food, beauty, or editorial markets. Contains insights and images from top pros. *$29.95 list, 7.5x10, 160p, 220 color images, order no. 1971.*

Backdrops and Backgrounds

A PORTRAIT PHOTOGRAPHER'S GUIDE

Ryan Klos' book shows you how to select, light, and modify man-made and natural backdrops to create standout portraits. *$29.95 list, 7.5x10, 160p, 220 color images, order no. 1976.*

Hollywood Lighting

Lou Szoke teaches you how to use hot lights to create timeless Hollywood-style portraits that rival the masterworks of the 1930s and '40s. *$34.95 list, 7.5x10, 160p, 148 color images, 130 diagrams, index, order no. 1956.*

Christopher Grey's
Posing, Composition, and Cropping

Make optimal image design choices to produce photographs that flatter your subjects and meet clients' needs. *$29.95 list, 7.5x10, 160p, 330 color images, index, order no. 1969.*

500 Poses for Photographing High School Seniors

Michelle Perkins presents head-and-shoulders, three-quarter, and full-length poses tailored to seniors' eclectic tastes. *$34.95 list, 8.5x11, 128p, 500 color images, order no. 1957.*

75 Portraits by Hernan Rodriquez

Conceptualize and create stunning shots of men, women, and kids with the high-caliber techniques in this book. *$29.95 list, 7.5x10, 160p, 150 color images, 75 diagrams, index, order no. 1970.*

LED Lighting:

PROFESSIONAL TECHNIQUES FOR DIGITAL PHOTOGRAPHERS

Kirk Tuck's comprehensive look at LED lighting reveals the ins-and-outs of the technology and shows how to put it to great use. *$34.95 list, 7.5x10, 160p, 380 color images, order no. 1958.*

Legal Handbook for Photographers

Acclaimed intellectual-property attorney Bert Krages shows you how to protect your rights when creating and selling your work. *$29.95 list, 7.5x10, 160p, 110 color images, order no. 1965.*

Modern Bridal Photography Techniques

A behind-the-scenes look at some of Brett Florens' most prized images—from concept to creation. *$39.95 list, 7.5x10, 160p, 200 images, 25 diagrams, order no. 1987.*

Just Available Light

TECHNIQUES FOR DIGITAL PHOTOGRAPHERS

The Deutschmanns show you how to capture high-end images of portrait and still-life subjects. *$19.95 list, 7.5x10, 96p, 220 color images, order no. 1981.*

THE DIGITAL PHOTOGRAPHER'S GUIDE TO **Natural-Light Family Portraits**

Jennifer George teaches you how to use natural light to create cherished portraits. *$34.95 list, 8.5x11, 128p, 180 color images, index, order no. 1937.*

Studio Lighting Anywhere

Joe Farace teaches you how to overcome lighting challenges and ensure beautiful results on location and in small spaces. *$34.95 list, 8.5x11, 128p, 200 images, index, order no. 1940.*

CHRISTOPHER GREY'S
Vintage Lighting

Re-create portrait styles popular from 1910 to 1970 or tweak the setups to create modern looks. *$34.95 list, 8.5x11, 128p, 185 color images, 15 diagrams, index, order no. 1945*

Lighting Essentials

Don Giannatti's subject-centric approach to lighting will teach you how to make confident lighting choices and flawlessly execute images that match your creative vision. *$34.95 list, 8.5x11, 128p, 240 color images, index, order no. 1947.*